Remy de G

The Angels of Perversity

translated by Francis Amery

DEDALUS/HIPPOCRENE

Dedalus would like to express its gratitude to the French Ministry of Foreign Affairs for its assistance in producing this translation.

Published in the UK by Dedalus Ltd,
Langford Lodge, St Judith's Lane, Sawtry, Cambs, PE17 5XE

UK ISBN 0 946626 81 2

Published in the USA by Hippocrene Books Inc,
171, Madison Avenue, New York, NY10016
US ISBN 0 7818 0004 8

Distributed in Canada by Marginal Distribution,
Unit 103, 277, George Street North, Peterborough, Ontario, KJ9 3G9

First English edition 1992
The translations of The Faun/Don Juan's Secret/Danaette first appeared in *The Dedalus Book of Decadence* (1990), Pehor in *The Second Dedalus Book of Decadence* (1992) and The Red Marguerite in *Scheherezade* (1992)

Translations (unless otherwise stated) & Introduction © Francis Amery 1992
The Faun/Don Juan's Secret/Danaette © Brian Stableford 1990

Printed in England by Clays Ltd, St Ives plc

Dedalus would like to express its gratitude to David Blow for his help in originating the Decadence from Dedalus Series and to Dr W. M. S. Russell for his assistance in translating the Latin passages in "Le fantome".

DEDALUS EUROPE 1992
supported by the European Arts Festival
July–December 1992

EUROPEAN ARTS
FESTIVAL
JULY–DECEMBER 1992

At the end of 1992 the 12 Member States of the EEC will inaugurate an open market which Dedalus is celebrating with a major programme of new translations from the 8 languages of the EEC. The new translations will reflect the whole range of Dedalus' publishing programme: classics, literary fantasy and contemporary fiction.

From Danish:

The Black Cauldron – William Heinesen

From Dutch:

The Dedalus Book of Dutch Fantasy – editor Richard Huijing

From Dutch/French:

The Dedalus Book of Belgian Fantasy – editor Richard Huijing

From French:

The Devil in Love – Jacques Cazotte
Angels of Perversity – Remy de Gourmont
The Dedalus Book of French Fantasy – editor Christine Donougher
The Book of Nights – Sylvie Germain
Le Calvaire – Octave Mirbeau
Smarra & Trilby – Charles Nodier
Monsieur Venus – Rachilde

Further titles will be announced shortly.

French Literature from Dedalus

French language literature in translation is an important part of Dedalus' list, with French being the language par excellence of literary fantasy.

French books from Dedalus include:

Seraphita – Balzac £6.99
The Quest of the Absolute – Balzac £6.99
The Devil in Love – Jacques Cazotte £5.99
Les Diaboliques – Barbey D'Aurevilly £6.99
Angels of Perversity – Remy de Gourmont £6.99
La–Bas – J. K. Huysmans £7.99
En Route – J. K. Huysmans £6.99
The Cathedral – J. K. Huysmans £6.99
The Phantom of the Opera – Gaston Leroux £6.99
The Diary of a Chambermaid – Octave Mirbeau £7.99
Torture Garden – Octave Mirbeau £7.99
Le Calvaire – Octave Mirbeau £7.99
Smarra & Trilby – Charles Nodier £5.99
Tales from the Saragossa Manuscript – Jan Potocki £6.99
The Mysteries of Paris – Eugene Sue £6.99
The Wandering Jew – Eugene Sue £9.99
Micromegas – Voltaire £5.99

forthcoming titles include:

The Dedalus Book of French Fantasy – ed Christine Donougher
The Book of Nights – Sylvie Germain
Monsieur de Phocas – Jean Lorrain
The Year 2440 – Louis Sebastien Mercier
Bruges la morte – G. Rodenbach

Contents

INTRODUCTION

by Francis Amery

Remy de Gourmont was born in 1858, of an aristocratic line which had suffered a decline in its fortunes, mainly due to the depredations of the English during the Napoleonic wars. At the age of ten his family left the Château de la Motte at Bazoches-en-Houlmes, where he had been born, and took up residence in the somewhat less grandiose Manoir de Mesnil-Villeman not far from Coutances, where he went to school. He was, as a matter of course, received into the Roman Catholic Church. In 1876 he went to Caen to study law, but did not stay long; the following year his parents gave him leave to continue his studies in Paris.

Gourmont knew before leaving for the capital that he did not intend to make a career in the legal profession. He confided to his personal diary his intention to devote himself to "l'amour et les livres", scrupulously noting that love would enable him to develop the sensual aspect of his personality, and books the intellectual aspect. He was to remain permanently preoccupied with notions of personal evolution and self-development, and with the supposed divisions, balances, tensions and contradictions inherent in the idea of the self. He was perpetually fascinated by dichotomies of all kinds: male and female; thought and emotion; materialism and idealism; God and man. His intellectual exploration of the dynamics of such complementarities and oppositions drew him into all manner of heresies, but no matter what challenges he posed to the religious and aristocratic ideals which he had inherited he never entirely cast them aside. If he ever became an atheist, he nevertheless remained a thoroughly *Catholic* atheist, and however radical his moral philosophy became he was

never in the least attracted by socialist politics; he remained a diehard elitist utterly contemptuous of "the rabble".

In 1881 Gourmont applied for a post in the Bibliothèque Nationale, although the stipend was scarcely sufficient to meet his living expenses. His early work included the preparation of a series of educational books for young readers. He also began publishing articles in periodicals, including *Le Monde* and *La Vie Parisienne*. His first novel, *Merlette* (1886), is generally considered to be awkward and naive; the manuscript of a second, *Patrice*, was lost by the journal to which it was submitted – a loss which he does not seem to have regretted for very long. Whether his early adventures in love were as dubiously satisfactory as these early literary endeavours it is hard to tell, although people who knew him in those days confirmed that he was a handsome young man before he fell prey to disfiguring disease. His romantic aspirations took a decisive new turn, however, in 1887, when he met Berthe Courrière.

Berthe was six years his senior, and her aristocratic pretensions – she preferred to style herself Berthe *de* Courrière – were sufficiently specious that even Rachilde, who was no stranger to the business of fantastic self-aggrandisement, felt free to describe her as a "horribly bourgeois fantasist"; nevertheless, she captivated Gourmont. His early letters to her were posthumously published as *Lettres à Sixtine*, clearly associating her with the heroine of his first successful novel *Sixtine* (1890; tr. as *Very Woman*, 1922), and there is no doubt that *Le fantôme* (1891; tr. herein as *The Phantom*) is an account of their affair, albeit highly transfigured by jaundiced hindsight.

Berthe fancied herself a serious student of the occult arts, having thrown herself wholeheartedly into the kind of lifestyle fantasy which had become popular in Paris in the wake of the self-styled "Eliphas Levi" (Alphonse Louis Constant). She knew Joséphin Péladan, the would-be Rosicrucian magus whose turgid novels railing against the cultural and spiritual decadence of contemporary France helped to popularise the idea of "Decadence" as a style and

a literary movement. She also knew Joris-Karl Huysmans, having become closely acquainted with him while he was conducting the explorations of the Parisian occult demi-monde that were to be incorporated into his classic novel of contemporary Satanism *Là-Bas* (1891); the character of Mme de Chantelouve is said to be partly based on her.

Berthe widened Gourmont's horizons considerably, in both erotic and social terms. She introduced him to Huysmans, and for a while the two became fast friends, although the alliance broke up, partly because Huysmans threw himself back into the arms of the Church while Gourmont drifted further away into the realms of exotic heresy. Like Huysmans, Gourmont became a great admirer and early supporter of the poetry and prose-poetry of Mallarmé, and Huysmans undoubtedly encouraged his decision to develop Symbolist techniques of his own with a fervour which would exceed Mallarmé's.

Gourmont formed other equally-important friendships at the same time, one of the most significant being with Villiers de l'Isle Adam, with whom he had much in common – like Gourmont, Villiers was an aristocrat fallen on hard times. The failure of Villiers' attempts to marry for money had embittered him against the world and against the female sex in particular, and Gourmont was soon to drink as deeply from his own cup of bitterness. The sub-genre of *Contes cruels* to which Villiers had given a name in his collection of 1883 paraded a kind of haughty cynicism which Gourmont found attractive, and which infected his own work to a degree clearly manifest in the erotic fantasies which he collected under the title *Histoires magiques* (1894; tr. herein as *Studies in Fascination*). Alas, this friendship did not even last as long as Gourmont's association with Huysmans; it was cut short in 1889 when Villiers died.

Gourmont also became friendly with Alfred Vallette, the husband of the amazing Rachilde, whose exotically erotic novels – including *The Marquise de Sade* (1887) and *Monsieur Vénus* (1889) – were among the central works of

the short-lived Decadent Movement. This association proved far more durable; Gourmont assisted Vallette in the founding of the *Mercure de France* in 1890, and became one of its most prolific contributors. It was for this journal that Gourmont was to do much of the work which made his name in 1890-91, although the respect which he eventually earned was initially preceded by notoriety, occasioned by a contemptuous article for the *Mercure* on "Le Joujou-Patriot-isme". This piece so offended the establishment that he was dismissed from his post at the Bibliothèque Nationale. The ensuing scandal provoked contributions from Catulle Mendès and Octave Mirbeau, among others, although the anarchist Mirbeau – whose support Gourmont presumably regarded as a mixed blessing – had difficulty finding a publisher for his own even more outspoken comments.

Later, Gourmont made a friend of the young Alfred Jarry, whom he met in the offices of the *Mercure de France* in 1894. He collaborated with Jarry on *L'Ymagier* (1896), and exerted a significant influence on the development of the younger writer, but as with Huysmans the association was eventually split by an irreconcilable difference of opinion.

Although his first publication – the text for an illustrated educational book on the eruption of a volcano – had been issued in 1882 and he had been a reasonably prolific writer ever since, the work which Gourmont did in the period 1889-91 marked a new beginning. It was in this period that he wholeheartedly embraced Symbolist techniques and culti-vated a thoroughly Decadent sensibility (although he later objected to the perversion of meaning inherent in the use of the label "Decadent"). His fiction of the period consisted mainly of brief *contes*, and there is a considerable grey area where these overlap with his experiments in prose-poetry. His one and only subject matter was sex; he was deeply fascinated by the essential capriciousness of the sexual im-pulse, by the ill-effects of social and religious repression of sexuality, and by the intellectual strategies which might

maximise the quasi-transcendental experience of sexual rapture.

The present volume assembles a good deal of the fiction which Gourmont published in the years in question. Although the short novel *Le fantôme* was first issued in book form in 1893 it had earlier appeared in the *Mercure de France* in 1891, and the majority of the *Histoires magiques* (which were collected in book form in 1894) had appeared in journals in 1890-91. There is in this fiction a good deal of creative exuberance and sheer literary virtuosity; it features extravagant play with the new-found world of symbolism: the symbolism of colours, of flowers, and of religious imagery is elaborately explored and developed. The proliferation of sexual symbolism in these works is extraordinary, echoing in advance much of the mapping that Freud was soon to do in *The Interpretation of Dreams*. In Gourmont's *histoires magiques*, as in Freudian dreams, *everything* is symbolic – but in Gourmont's tales, wish-fulfilment is at best only half the story, almost always followed by disillusionment.

From the very beginning, Gourmont was well aware of the mercuriality of sexual fulfilment, and the extreme difficulty of making the most of it. But the magnitude of his eventual disappointment was unusual, the commonplace effects of his growing disenchantment with Berthe Courri-ère being compounded and quickly overtaken by the appall-ing effects of the disease which ruined his life. In the two substantial works which concluded this phase, "Stratagems" and *Le fantôme*, one can easily see the after-effects of a decayed infatuation, but one can also see premonitions of a deeper and more sinister awareness of permanent loss.

The disease which began in 1891 to cast its blight upon Gourmont's features was known at the time as "tubercular lupus". As that name implies, it was widely assumed to be a species of tuberculosis. It is nowadays known as "discoid lupus erythematosus", and is generally thought to be caused by a virus, but even the modern pharmacopoeia has little to offer by way of effective treatment. It is not fatal, nor

even particularly debilitating in cases in which it does not develop into systemic lupus erythematosus, which affects the other organs of the body. The progress of Gourmont's case was limited but rapid. Initially, at least, it only affected his face – but to such an extent that it rapidly became the dominating fact of his life. It turned him into a recluse. His friends continued to visit him, but as time went by he became extremely reluctant to go out into a world where he was likely to be refused service in restaurants which he had previously patronised, and he became a virtual refugee in the world of his own imagination. Arthur Ransome appended to his translation of *A Night in the Luxembourg* a brief memoir of the author, in which he records that he found Gourmont, towards the end of his life, living on the fourth floor of a house in the Rue de Saints-Pères, dressed in a monk's robe and a grey felt cap. He placed his vistors on the far side of his huge desk, with the light carefully directed at their faces, away from his own. Ransome observes that Gourmont kept his hand in front of his face, but coyly does not say why – and most biographical sketches of Gourmont in English reference books make no mention of his disease, although no French reference book considers it unmentionable. One can only wonder what readers unaware of the truth of the matter made of Ransome's circumlocutory observation that the face which was once "beautiful in the youth of the flesh" had now become "beautiful in the age of the mind . . . vitalised by intellectual activity."

Having lost his position at the Bibliothèque Nationale, Gourmont had no alternative but to make his living entirely with his pen, and he set out to do so very methodically. In the course of the following quarter-century he produced enough work to fill fifty volumes, most of it taking the initial form of essays written for periodicals. His non-fiction covered a wide range, from his early study of mysticism and symbolism in Medieval poetry, *Le Latin mystique* (1892) to his remarkable study of the natural history of sexuality,

Physique de l'amour: Essai sur l'instinct sexuel (1903; tr. as *The Natural Philosophy of Love*, 1922). He became one of the most respected literary critics of his day. He also helped to interpret and popularise the philosophical ideas of Schopenhauer and Nietzsche, and made his own distinctive contributions to the development of aesthetic philosophy.

He was to write four more novels: *Les Chevaux de Diomède* (1897; tr. as *The Horses of Diomedes*, 1923); *Le Songe d'une femme* (1899; tr. as *Dream of a Woman*, 1927); *Une Nuit au Luxembourg* (1906; tr. as *A Night in the Luxembourg*, 1912); and *Une Coeur virginale* (1907; tr. as *A Virgin Heart*, 1921). These works are, however, very different from the work of his early Symbolist period, whose climactic phase came to an end with the fervent heretical drama *Lilith* (1892) and the various short stories and prose-poems which were collected in *Proses moroses* (1894), *Le Pèlerin du silence* (1896) and *D'Un pays lointain* (1898). Much of the work in these collections dates from the 1889-91 period, notably "Le Pèlerin du silence", a *nouvelle* dedicated to Mallarmé which appeared in the *Mercure de France* in 1890. In the later part of his career Gourmont produced only one more volume of short pieces, *Couleurs* (1908), and even that had to be padded out with material reprinted from *Proses moroses*. But not all his non-fiction was scholarly; his reclusiveness did not prevent him from being a prolific letter-writer, and some of his less formal later works take the form of quirky epistles, including the ironic and imaginary *Lettres d'un satyre* (1913; tr. as *Mr Antiphilos, Satyr*, 1922) and the philosophical and authentic *Lettres à l'Amazone* (1914; the addressee was Natalie Barnay). The latter book was published the year before he died, serving as a suitably eccentric swan song.

As noted above, the subject of all Gourmont's fiction is sex, but his attitude to that subject changed considerably over time, although it never remotely approached fashionability. Gourmont was, in a way, a direct literary descendant of Théophile Gautier, much of whose fiction consists of

erotic fantasies which lament the failure of actual sexual relationships to live up to the ideals of the imagination. But Gautier achieved a compromise in life which is reflected in the self-indulgence of much of his fiction; while elevating the ballerina Carlotta Grisi to the status of a Platonic ideal he served his sexual appetite by sleeping with her sister Ernesta. Gourmont is less sentimental and more relentlessly analytical than Gautier; he can never be content to dwell in fantasy-worlds because his intelligence rips them to shreds almost as soon as they are formulated, and he is perpetually entranced by the apparent absurdity of sexual attraction. The impossibility of actually achieving a satisfactory sexual relationship undoubtedly disappointed Gautier, but Gautier was prepared to make the best of what he had, both materially and imaginatively. For Gourmont that impossibility – once he had convinced himself of it – was a more profound tragedy, an expression of the essential perversity of existence; and yet the perversity itself became a topic of intense interest to him, to be investigated and described and explained as fully as possible.

The works assembled in this volume represent early endeavours in this regard. The *histoires magiques* are really neither "tales" nor "magical"; they are a series of case-studies in sexual attraction, mapping the capricious forms which erotic attraction takes, and the sometimes-bizarre behaviours which result from its channelling. Where they become explicitly supernatural they do so purely by symbolic extension, although the sexual impulse itself is here represented as a quasi-supernatural force. It was the Catholic Church's attitude to sexuality, more than any purely doctrinal objection, which drove Gourmont to embrace attitudes so heretical that some people would indeed consider their literary expressions blasphemous. He was completely at odds with the Church's repression of sexuality, considering the social and psychological consequences of that repression to be appalling. "Péhor", the story which Gourmont selected to open the sequence of his *histoires magiques*, is a straightforward account of a young girl

brought to destruction by her own sexuality, perverted by enforced ignorance and social pressure into a species of pious idolatry which cannot begin to satisfy her inner need. Here sexuality is symbolised by the eponymous demon, who was a tribal god before he was condemned as fallacious by the followers of Jehovah, when his status was automatically redefined as evil. The demon's attentions are fatal, but the venereal disease which kills poor Douceline so horribly is something which shelters beneath the cloak of secrecy which the church has spread over the entire spectrum of sexual impulse and expression.

Before his disillusionment became complete, Gourmont was sufficiently inspired by the possibilities of sexual experience to endeavour to rework theology and ritual so as to produce a more honest and more life-enhancing species of Christianity, and the primary result of this endeavour is the transfiguration of the Mass outlined in *Le fantôme*. Unfortunately, this is unsuccessful even in its own terms. In order to redeem the perverse demons of sexuality one must do more than simply redefine them as angels, for the retention at the core of a re-sexualised religion of all those martyred saints and the crucified Christ inevitably places a kind of sado-masochism at the presumed heart of sexual experience – a move which the protagonist of "Le fantôme" ultimately finds self-defeating. Other strategies outlined in the various *histoires magiques* are similarly revealed as direly destructive or ultimately self-contradictory.

Later in his career, Gourmont laid aside the elaborate metaphorical coat-of-many-colours which decorates – but also confines – the works in this volume. He abandoned the intricate network of symbolic references which is displayed here in favour of a very different ideative context. He was aided in making this move by his reading of Nietzsche, whose attacks on the life-denying aspects of Christianity were even fiercer than his own, and whose interest in venturing "beyond good and evil" to a new and better morality he shared. He combined this influence, rather eccentrically, with inspiration obtained from his

reading of the works of the celebrated entomologist J. H. Fabre and other contemporary naturalists and evolutionists. He drew upon observations made by Fabre and others to construct a "physiology of sex" which placed human sexuality firmly in the context of a universal, multi-faceted and intrinsically eccentric biological phenomenon.

Given the astonishing range of sexual behaviours to be found in the animal kingdom, especially among the invertebrates, the whimsicality of the human sexual impulse came to Gourmont to seem entirely expectable. In *Physique de l'amour* and many other essays he extensively elaborates an argument briefly cited (credited to Schopenhauer) in *Le fantôme*, to the effect that there is no *fundamental* difference between intelligence and instinct, and that the phenomena of the human mind cannot and should not be attributed to the workings of some divinely-created soul which merely uses the body as a habitation. In this view, the variety of human sexual behaviour becomes a mere phenomenon of nature, to which moral commandments are essentially irrelevant:

"There are species in which the position of the organs is such that the same individual cannot be at the same time the female of the one for whom he is the male, but he can at that moment when he acts as male, serve as female to another male, who is female to a third, and so on. This explains the chaplets of spintrian gasteropods which one sees realizing, innocently and according to the ineluctable law of nature, carnal imaginings of which erotic humanity boasts. Viewed in the light of animal customs, debauchery loses all its character and lure, because it loses all claim to immorality. Man, who united in himself all the aptitudes of the animals, all their laborious instincts, all their industries, could not escape the heritage of their sexual methods: and there is no lewdness which has no normal type in nature." (1)

The literary extension of this philosophy is seen in *Une coeur virginale*, which carries a preface explaining that it ought to be deemed a "physiological novel". It is, in

essence, an elaborate account of how mate-choice in humans ought to transcend the customary romantic illusions, allowing itself to be dictated instead by the complementarity of physical needs – a complementarity which is much better reflected in the patterns of conventional immorality than in the sentimental mythology of "falling in love". The uncompromising cynicism of this attitude – which leads to a bitterness more extreme, in its way, than the *conte cruel* aspects of the *histoires magiques* – is manifest in the reflections of several of the characters in *Une coeur virginale*, in such passages as this:

"He had often pondered on the mystery of intelligence among children. How is it that these subtle creatures are so quickly transformed into imbeciles? Why should the flower of these fine graceful plants be silliness?

" 'But isn't it the same with animals, and especially among the animals that approach our physiology most closely? The great apes, so intelligent in their youth, become idiotic and cruel as soon as they reach puberty. There is a cape there which they never double. A few men succeed; their intelligence escapes shipwreck, and they float free and smiling on the tranquillized sea. Sex is an absinthe whose strength only the strong can stand; it poisons the blood of the commonalty of men. Women succumb even more surely to this crisis.' " (2)

The extrapolation of these ideas provides a series of excuses for Gourmont's particular species of misogyny, whose beginnings – which may owe as much to the influence of the woman-hating Villiers de l'Isle Adam as to the disenchanted aftermath of his affair with Berthe Courrières – can be seen in "Le fantôme". By the time he wrote *Une Coeur virginale* he was easily able to make such off-hand observations as:

"Women are ruminants: they can live for months, for years it may be, on a voluptuous memory. That is what explains the apparent virtue of certain women; one lovely sin, like a beautiful flower with an immortal perfume, is enough to bless the days of their life." (3)

The ideas of this phase in Gourmont's career were a significant influence on the theories of that other well-known misogynist Ezra Pound, who had assisted in the translation of the earlier novel *Les Chevaux de Diomède* as well as composing the English version of *Physique de l'amour*. It is notable, however, that Gourmont's last novel, *Une Nuit au Luxembourg*, drifts nostalgically back to a more sentimental view of womanhood, which is reclothed in a contentedly pagan religious imagery. It seems that his dreams became more of a consolation to him as his long exile progressed, and that he was forced in the end to a lachrymose lamentation of the evil circumstances which had thwarted his ambition fully to complement the education of *les livres* with that of *l'amour*.

Gourmont's attitudes to the world in general may be seen as an extension of his attitudes to sex, although he – like most people – would presumably have put it the other way around. Early in his career, under the influence of Schopenhauer, he became an out-and-out idealist, and found the rejection of materialism liberating. In *Le Livre des masques* (1896) he summed up his position thus: "The world is my representation. I do not see what is; what is, is what I see. So many thinking men, so many and perhaps different worlds. This doctrine, which Kant left on the way to go to the assistance of shipwrecked morality, is so beautiful and so supple that it can be transposed without harming free logic from theory to even the most exacting practice, a universal principle of emancipation for every man capable of understanding it." (4)

The intellectual liberation which Gourmont derived from such ideas is perhaps most extravagantly displayed in *Le Chemin de velours* (1902), whose "velvet road" is strewn with a host of slick quasi-Nietzschean aphorisms:

"Christianity is a machine for creating remorse, because it is a machine for diminishing the subtlety, and for restraining the spontaneity, of vital reactions . . . What a triumph for the Jews to have forged for the multitude of Philistines such an instrument of degeneration!" (5)

And:

"It becomes certain that human intelligence, far from being the object of creation, is only an accident, and that moral ideas are merely vegetable parasites born from an excess of nutrition." (6)

Such comments as these demonstrate that Gourmont's journey into solitude, however much it may have been forced upon him, was a bold and determined one, and that he carried with him in his intellectual baggage instruments for the amelioration of his condition. He cut himself off not merely from his social and religious heritage but also from those aspects of contemporary philosophy which were useless to him; but the pride he took in being an individual, a man apart in every possible way, demanded respect with an ironically seigneurial *hauteur*. He earned that respect with both the quality of his scholarship and the individuality of his outlook. He became the leading literary critic of his day not merely by the breadth of his reading and the penetration of his intelligence, but also because he had a unique sympathy with many of the writers whose reputations he helped to establish and secure. He understood better than any other commentator the profound feelings of disenchantment, cynicism and alienation which the writers of the *fin de siècle* inherited from Baudelaire and Lautréamont, and elevated as bloody banners of their own triumphant distress.

Although he enjoyed a high reputation in his own time – Anatole France once referred to him as "the greatest living French writer" – Remy de Gourmont is not much read today. He is little known in England even as a critic, and hardly at all as a writer of fiction. This is partly because the greater part of his fiction was long considered to be too risqué for translation. Arthur Ransome's preface to *A Night in the Luxembourg* is defensive in the extreme, anxiously anticipating charges of indecency and blasphemy. In fact, the book was simply ignored.

The only other novel of Gourmont's which is known in

England is *A Virgin Heart*, whose publication here was presumably assisted by the fact that its translator was Aldous Huxley. Such English versions as there are of his other works were produced in America, where he was more highly regarded, but with the notable exception of the Pound version of *The Natural Philosophy of Love* his books never became significant elements of that dubiously celebrated "naughty library" of French books which were produced in illustrated editions "for private circulation only"; in consequence. he missed out on the kind of notoriety which attached itself to writers like Pierre Louÿs.

Few of Gourmont's short stories have ever been translated into English, with the surprising exception of the somewhat anaemic stories original to *Couleurs*, which appeared twice in America – as *Colors* – in editions issued by the fancifully-named Blue Faun Press and Panurge Press. It is notable that the version of "The White Dress" which was prepared for the twenty-volume *The Masterpiece Library of Short Stories* in the 1920s is carefully distorted in its implications by a translator unsympathetic to its bitterness, although the version of "The Magnolia" which appears alongside it retains the nasty-mindedness of the original. The present volume will hopefully begin to redeem this aspect of Gourmont's work from its long neglect.

Remy de Gourmont cannot have considered himself – as some others certainly did consider him – to have been a man "born out of his time". We know this because he poured scorn on the very idea of a man's being born out of his time. In a memoir of Villiers de l'Isle Adam published in *Le Livre des masques* he cited such judgments as instances of "disturbed admiration", and opined that "a great writer is inevitably by his very genius one of the syntheses of his race and epoch ... the brain and mouth of a whole tribe and not a transient monster" (7). But he was never afraid of apparent contradictions, especially if they were suitably ironic, and he came close to delivering some such judgment himself a mere two years later, in *Le Deuxième livre des masques* (1898), when he turned his attention to the work

of a less celebrated writer. It is difficult to believe, reading what he wrote then, that he could have passed any other judgment on his own life or his own work:

"Some men are not in harmony with their time; they never live with the life of the people; the soul of crowds does not seem to them very superior to the soul of herds. If one of these men reflects on himself and comes to understand himself and to place himself in the vast world, he may grow sad, for about him he feels an invincible stretch of indifference, a mute Nature, stupid stones, geometrical movements; a great social solitude. And from the depths of his ennui he thinks of the simple pleasure of being in harmony, of laughing naturally, of smiling in an unreserved way, of being moved by long commotions. But there may come to him a pride in his renunciation and his isolation, whether he has adopted the pose of a pillar-hermit or whether he has shut the gates of a palace on his pleasures." (8)

REFERENCES

(1) *The Physiology of Love* New York: Rarity Press, 1932. p.86.
(2) *A Virgin Heart* New York: Modern Library, 1925. p.160–1.
(3) *ibid* p.195.
(4) *Remy de Gourmont: Selections from All His Works Chosen and Trans-lated by Richard Aldington* New York; Covici-Friede, 1929. p.346.
(5) *ibid* p.422.
(6) *ibid* p.423.
(7) *ibid* p.353-4.
(8) *ibid* p.361-2.

STUDIES IN
FASCINATION

PÉHOR*

Sensitive though poor, imaginative though forever hungry, Douceline learned early in life to delight in caresses and embraces. She loved to pass her hands across the cheeks of little boys, and to put her arms around the necks of little girls, stroking them as she might have stroked a cat. She loved to kiss the knitted fingers of her mother's hands, and whenever she was banished to the corner to do penance for her petty sins she would occupy herself in kissing her own palms and her own arms, and the bare knees which she would raise up to her lips one by one.

Such was her curiosity in respect of her sensations that she was quite untroubled by modesty or shame. If she were scolded, roughly or ironically, for her narcissistic amorousness she would firmly deny that there was anything excessive in her tenderness, while hiding her eyes behind her hands. In secret, however, she maintained the habit of caressing herself, never admitting that it might qualify as a vice. She became so adept in concealing her predilection, even from herself, that she reserved her most intimate attentions to times when she was safely asleep.

When the time came for her first communion Douceline was enthralled by all the solemn preparations which had to be made. She was thrilled to be given a few sous in order to buy a holy picture of the kind which all the females of the region mounted upon their walls.

* Péhor was a god of the Midianites, one of the many rival tribal deities demonized by the Children of Israel at the behest of their own jealous God; the name is rendered Baal-peor ("master of the opening") in the Authorised Version of the Old Testament. *Numbers* 25 describes how Phineas, the son of Eleazer, obeys Moses' command to punish those Israelites who have "committed whoredom" with Midianite women by killing Zambri (Zimri in the A.V.), son of Salu, and Cozbi, daughter of Sur (Zur in the A.V.). Phineas slew them both with a single blow of his spear, presumably while they were copulating.

The images of the Holy Virgin did not attract her; Douceline preferred the portraits of Jesus, especially those which displayed his most gentle expressions – the ones which tinted his cheeks with rouge, and painted his beard with flames, and set his blue eyes alight with the reflected glow of a diffuse aureole. One picture of Jesus which she saw had a visitant nun at his feet, bathing in the glow of his redly shining heart and declaring: *My saviour is everything to me and I am everything to him*. In another he looked down, tenderly and a little ambiguously, at a worshipper who proclaimed: *The sight of his eyes has blessed my heart*.

One image, in which the Sacred Heart was pierced by a dagger, dripping blood the colour of red ink, carried a legend which debased one of the most beautiful metaphors of mystical theology: *The Lord's gift to his most favoured children is the wine which intoxicates the souls of the innocents*. The Jesus from whose breast that jet of carmine sprayed had an infinitely loving and reassuring face, a blue robe decorated with little golden flowers, and delicate – almost translucent – hands where two tiny stars were made captive. Douceline adored this image absolutely, and when it became hers she made a vow, writing on the back of the picture: *I give myself to the Sacred Heart of Jesus, because it is given to me*.

Frequently thereafter, when she looked up from her half-open missal, Douceline would lose herself in contemplation of that loving and reassuring face, murmuring without opening her mouth: "To you! To you!"

As far as the mystery of the Eucharist was concerned, Douceline understood nothing of its intended significance. At communion she received the host without emotion, without any remorse for her incomplete and insincere confessions, without any experience of holy affection. Her heart was entirely reserved for the loving and reassuring face.

Douceline finally succeeded, by the force of dogged perseverance, in memorising the catechism. She noted therefrom

the preference which Jesus had for beautiful souls and his corollary disdain for beautiful faces, and afterwards spent hours looking at herself in a mirror, utterly dismayed to find herself so pretty. Chagrined by this discovery, she prayed so fervently to become plainer that she gave herself a fever, awakening one morning with pustules all over her face.

In the delirium which attended her illness she proffered grateful words of love; when she had recovered she thanked Jesus effusively for the white pockmarks which now marked her forehead and cheeks. She offered up these thankful prayers while kneeling on a hard stone floor, and when her grazed knees bled she kissed the wounds and sucked up the blood, saying to herself: "This is the blood of Jesus, because he has given me his own heart".

During the weeks which passed while she was weakened by the anaemia which followed her fever her secret habit was once again revealed to her conscious mind. She would occasionally wake to discover herself engaged in her caresses, but would quickly abandon them and return to sleep. One night, though, she woke to find her fingers sticky with blood. She was very frightened, and quickly got up to wash herself, but the blood had stained her nightgown too, and seemed to be everywhere.

Her mother was fast asleep. Fearfully, Douceline snatched up the consecrated picture from the shelf where she had placed it, and turned it around so that she might hide herself from the face of Jesus. She took off her nightgown and got dressed, all a-tremble; then she took the picture out into the fields, and buried it.

She returned, weeping and nearly fainting, to the house. Her mother had awakened by that time, and took care to explain to her what had occurred. Douceline accepted the explanation, as she was bound to do. Nevertheless, she could not believe that what had happened was entirely natural. She felt bitterly resentful of the fact that her own Jesus, whom she had felt compelled to suffocate beneath the soil, had borne silent witness to her sin and degradation. That Jesus now seemed to her to be dead.

When her mother went back to bed, though, Douceline tried to calm herelf by recalling to mind the stories she had been told of the lives of the saints. As she drifted back to sleep herself, all the strange names which she had stored up in her head while listening to sermons and legends seemed to echo in her ears like the sound of bells. She continued to hear them tolling, louder than the peals which called the faithful to mass on Sundays, as she slipped into a dream; but one name gradually separated itself from all the rest, sounding and resounding within the imaginary chimes:

Pé-hor – Pé-hor – Pé-hor – Pé-hor.

Demons are like obedient dogs; they come when they are called. Péhor loves the daughters of men, and still remembers fondly the days when he excited the passions of Cozbi, daughter of that Sur who was prince of the Midianites. Péhor came in response to Douceline's call; he was drawn to her by the combined attraction of her freshly-attained puberty and her earlier self-pollution. He took up his chosen lodging in the inn of her vice, where he consented to be caressed, relishing the carnal attentions of her feverish hands, without any fear that he might suffer here the kind of blow with which, in olden times, Phineas had simultaneously cut short the delights of Cozbi and the pleasures of Zambri, while the son of Salu was entered in the body of the daughter of Sur.

Although it was the middle of the night, the room was illuminated by the demon's presence. All the objects in it were haloed with light, as though they had become luminous themselves and had acquired the power to radiate warmth.

All was calm, and a ruddy shadow seemed to descend upon Douceline, closing all the doors of her perception. Then, ecstasy came.

Douceline savoured the moment of pleasure's arrival, and all the thrilling frissons which travelled the length and breadth of her body before eventually becoming localised. The red shadow which lay upon her was interrupted and traversed by messenger lights which insinuated themselves

into every fibre of her being, dancing to a rapid rhythm. In the end, there was an explosive sensation like the bursting of a skyrocket: an exquisite *crack* which flashed within her brain and down her spine, through the marrow of her bones and into all her mucous membranes, hardening the nipples of her breasts. All the silken hairs which dressed her skin were elevated; stirred up as grass might be stirred when lightly brushed by a skimming breeze.

After the last quiver of her startled flesh, the valves of her heart seemed to open wide, and the filtered pleasure coursed through her veins to touch every cell in her body.

Péhor, at that moment, rose up out of his hiding-place and magnified himself, growing swiftly into the image of a beautiful young man. Douceline, who was by now beyond the reach of astonishment, admired and loved him upon the instant. She laid her head upon his shoulder, and fell contentedly asleep, conscious of nothing save for the fact that she was gladly held in the embrace of Péhor.

From that night on, Douceline's life continued in a similar fashion. By day she delighted herself with the memory of her nights, recapitulating her delectation by dwelling luxuriously upon the impudicity of her encounters, upon the acuity of the caresses and the crushing pressure of the kisses of the invisible and intangible Péhor. She gloried in the languorous pleasures which continued to surge within her, almost magically, after that first sweetly-perfumed eruption of joy.

What a being Péhor was! She never wondered, though, what *manner* of being he might be; she was heedless of everything save for the enjoyment. The multiplicity of the spasms which overcame her reduced her to an animal level of consciousness, and she lived in a carnal dream.

In constantly renewing her solitary debauchery, she played the part of the virginal Psyché, abandoning herself to whatever dark angel cared to claim her. She had neither the strength of will nor the reticence to resist; she did not care whether her visitant came clad in rust-red shadows or fulgurant with cerebral light.

Douceline had reached the age of fifteen when, in the shed where her family's milch-cow was kept, an itinerant peddler of religious tracts took advantage of her enervated state of mind to press his attentions upon her. She let him do what he wanted, and did not suffer any pain or indignity at all while he did it, having already been amply deflowered by the demon of her audacious imagination. The man's lewd grunts and grimaces made him altogether ridiculous in her eyes, and when he looked at her – having straightened his clothing again – with an amorously fond expression she rose promptly to her feet and burst out laughing. Then she shrugged her shoulders and went away.

But she was punished for what she had allowed to be done to her: after that, Péhor came to her no more.

In the weeks that followed, she no longer dreamed about Péhor when she tended the cow in the shed; instead, she could not help but remember the peddler, and not altogether without shame. The incident had left its legacy, and she became afraid. She had seen pregnant women in church, lighting candles to the Holy Virgin and praying that they might safely be delivered of their burdens, and she in her turn lit a large candle and placed it on its spike, praying that her own belly might not swell up.

She recognised the fact that her demon had been exorcised, and took the opportunity to devote herself once again to her prayers. She began to avoid the cowshed, preferring to be on her knees on the paving stones of a small chapel where an image of Jesus was lodged. Here she took herself to look up into the loving and reassuring face, as she had so loved to do in earlier times.

Even without the interventions of Péhor, however, she continued to indulge her secret vice. But now it seemed that she had begun to be corroded by its effects: her cheeks became hollow, and she was continually seized by fits of coughing. She was so tormented in her sleep that she felt as if she might as well have spent her nights in the stinking straw of the cowshed, trampled by the hooves of the cow.

A morning eventually came when Douceline trembled so violently that she could not put on her stockings. She had to lie down again, and terrible pains began to afflict her belly. Her inflamed ovaries throbbed as though they were constantly being pricked by bundles of needles. From that morning on, she was unable to get up.

During the days which followed, as she lay in agony upon her desolate bed, she was frequently visited by fanciful dreams of an unexpected naïvety, which recalled to her mind the icons of her lost innocence. Her rapturous delusions showed her, in succession, God the Father, all clad in white like a priest she had once seen celebrating mass during Lent; St. John playing in the celestial groves with curly-fleeced and beribboned lambs; Our Lord, dressed all in gold with a long red beard; and the face of the Holy Virgin, smiling from a blue-tinted cloud.

In later days, however, these consoling apparitions abandoned her. It was as though the sky itelf had darkened above her, to reflect her more recent complicity with the demon. The hypocrisy of her child-like visions could not be sustained, and the impenitent sinner yielded herself again to the memory of the horrible infamies which she had celebrated with he whom she had chosen to be her eternal master. Péhor returned to lodge once again in the secret residence where she had consented to become impure.

Douceline felt herself ravaged afresh by the demon's caresses, which were now excruciating instead of tender. It was as though her flesh were being teased by stinging nettles or bitten by a great host of ants. Her ripened private parts were all engorged, opened up like a split fig, and they seemed almost to be rotting while she still lived.

While she endured the hours of unremitting agony the laughter of Péhor resounded in her belly like the changes rung on Maundy Thursday, which seemed to emerge from all the graves and tombs of humankind.

Péhor abandoned himself entirely to the hilarity of his demonic satisfaction, and to amuse himself further he

puffed himself up with rude vapours, which he let out loudly in gusts of noisome wind. Then he subjected her, as he had so often done before, to his amorous kisses – save that now he substituted mordant bites for ecstatic spasms. Douceline screamed in pain, but it seemed to her that Péhor cried out more strongly than she did, filling up her abdomen with the shrill stridency of his voice, and making it vibrate with resonance.

It seemed, as the end approached, that there began a great stir and bustle in the filthy haven where the demon had found asylum, which gradually spread through the pit of her stomach a terrible sensation of squeezing and choking.

Péhor was at last taking leave of his residence.

As he broke out of his hiding-place, Péhor drove his talons into Douceline's breast; he tore at her heart, and rent the soft spongy tissue of her lungs. Then her throat dilated, like the swollen neck of a serpent regurgitating the sticky remains of its digested prey, and a great gout of blood spurted from her mouth, ignominiously expelled as though by a drunken hiccup.

She was able to take one last breath, although she was very near to losing consciousness. Her eyes were closed, and her hands were cast wide; she floated upon the soft waves of the tide which fate sends to carry the damned away, like wrecked ships, to the abysmal depths of Hell.

She felt a single kiss applied very precisely to her lips: a kiss excrementally and purulently rank. Thus the soul of Douceline quitted the world: sucked in and swallowed up by the demon Péhor, and securely ensconced within his entrails.

THE WHITE DRESS

Oh, how sorry I was to leave the corner where, ungently rocked by the swaying of the carriage, I had dreamed of landscapes more exciting by far than the one through which we passed: the silent windmills, the lonely steeples, the gnarled apple-trees and the sad hovels, all asleep in the evening mist, beyond the reach of sunlight, laughter, sweat and tears.

I had come here to be the best man at the wedding of my old friend Alberic de Courcy. Politeness had compelled me to agree to his request for me to do so, although I am quite indifferent to such matters. It is not my habit to participate too enthusiastically in the celebrations of others, nor in their mourning, but I always conduct myself with affable dignity. I rely on my calmly apologetic smile to obtain forgiveness for the flashes of resentment which sometimes show in my eyes.

There was no one to meet me; I was not expected until the next morning. I was happy enough to make my own way, although it required me to walk through the woods for three-quarters of an hour. I avoided the open spaces and the insipid glare of the moon.

I was not overly worried about the prospect of arriving unannounced in the middle of the night, when everyone would be asleep. I knew my way around, thanks to my previous visits, and I assumed that the gate would not be locked.

No dogs howled as I entered; I was as stealthy as an artful thief.

As I crossed a lawn which was bordered by a great circular path, making a detour around a clump of lilac trees – what a sharp scent they had! – I caught sight of two lighted windows side by side in an otherwise featureless facade.

I headed straight for the windows, which were on the

ground floor. As I was about to tap on the glass I hesitated, and took the liberty of looking in to see what was happening there.

In the middle of a small and very untidy room three women were studying a white dress which they had displayed upon an armchair: a dress whose whiteness seemed as pure as the souls of the Holy Innocents. One of the women was Rosa, an old servant of the family. The second I recognised as Madame de Laneuil. The third was a young girl, the sight of whose face reminded me immediately of the innocent yet wholehearted affection of which we are capable as children – and of a time when two laughing girls in their first grown-up costumes had gravely given to Alberic and myself the flowers from their bouquets as if they were tokens of betrothal, and had permitted each of us the Holy Sacrament of a kiss!

How many years ago had that been? Ten, perhaps. Oh, how sweet the memory of youthful desire could be! How the blackbirds used to greet the dawn from the leaf-laden crowns of the chestnut-trees, in those wonderful days of yesteryear!

Since the death of Monsieur de Laneuil the house had been closed, but it had been reopened so that Alberic might wed his chosen bride here – and I had come to be a witness to his marriage, to confer upon it the unnecessary approbation of the world at large.

The two sisters were Edith and Elphège; Alberic was to marry Edith, the elder of the two. But which of the two was I looking at now, so fair and so pale? Was she so pale and tremulous because *she* was to be married tomorrow, or was she merely to be the bridesmaid, more anxious on the bride's behalf than the bride herself? *Which was she*, whose face had reawakened in my soul the memory of youthful passion and childhood affection?

It had to be Elphège. Undoubtedly, it was Elphège – Elphège the pale, Elphège the fair. . . .

Reassured by the phantom of reason which gripped me with its ironic hands, I revelled in the sight of her, delighted

and fascinated. I tantalised myself with the fantasy of a double wedding: two processions down the aisle; four cushions ranged at the feet of the presiding priest; four gold rings resting upon the plate . . . a veritable chain of gold to link our souls!

It was Elphège. It was Elphège, without a doubt, and I loved her! I loved her with such fervour that I could not believe that I had ever ceased to love her – not even for a single minute! – during all the long years I had been away.

It was true. I loved her! But then I seemed to see her more clearly: the laughter bubbling up within her smile; the eyes anticipating joys to come. The beautiful harmonies which had been aroused in my soul seemed suddenly plaintive and uncertain. I had too often seen rainbows appear to colour a sullen sky, and then fade again; I understood only too well how easily hopeful joy can turn to sadness; I knew how completely I had been disillusioned of that innocence which used to be mine, when the black birds greeted the dawn from the leaf-laden crowns of the chestnut trees.

The sharp scent of the lilacs confused me with a sudden dizziness. . . .

I reached out and rapped on the window.

The three women started in alarm.

When they had recovered from their surprise, Madame de Laneuil ordered Rosa to go to the window and draw aside the curtain. Rosa obeyed, putting her hand up to shade her eyes as she squinted into the darkness.

"Who's that?" she demanded of the shadow beyond the pane.

I called out my name. Madame de Laneuil hurried from the room, and the young girl laughed. It was Elphège, it had to be Elphège! What a wonderful welcome I was to have, in spite of my late arrival!

The door was unbolted and I entered. I was received by my hostess, who held up the lantern which she had seized in order to examine me closely, to make sure that it was really me, and not some artful thief.

"How pale you are!" she exclaimed, overriding my hesitant greeting.

I tried to excuse myself, protesting that it was mere appearance – a deceptive effect of the unusually pale moonlight.

"It must be affecting all of us in the same way!" she replied, obliquely, as she lowered the lantern. "Oh, what a bother it all is! Would you believe it? Everyone else – including Alberic – has been in bed for hours. Elphège is quite worn out, suffering from that strange disquiet which always afflicts girls whose sisters are to be married . . . I only wish Edith could be in bed too, to enjoy the innocent sleep appropriate to her last solitary night, but the wedding dress has only just come back from Paris . . . this white dress here! We wanted to make a small alteration . . . nothing at all . . . Rosa has been trying to pin it up . . . now it is too wide here! Too wide by *this* much!"

Madame de Laneuil held up her hand, with finger and thumb outstretched to indicate the magnitude of the problem.

"This much!" she repeated. "We are near to despair. We don't know what to do – we take up the scissors, one after another, but no one dares to cut – and yet it has to be done. We must make it fit, one way or another! I fear that the time has crept up on us. . . ."

My voice was as colourless as the magical dress as I said, trying impotently to feign indifference: "Before I rapped at the window I inadvertently caught sight of one of your daughters, which I took to be Elphège . . . I was certain that it was Elphège. . . ."

"They are so very similar in appearance, and it has been such a long time!" she replied. "Those were happy times – were they not? – when you were all so young. But we haven't time to stand here dreaming – come in! A man's calmness is just what we need at a time like this. . . ."

I could not move, and she had to repeat her invitation.

"Come in, please!"

When I followed her into the room, Edith greeted my

appearance with a questioning frown, evidently surprised that her mother had brought me here. Madame de Laneuil, who was no less conscious of the impropriety of my intrusion upon such a delicate business, immediately began to set things to rights by explaining, in good-humoured fashion, the reason for my presence. She took pains to stress that it was her own idea. . . .

As for me, I now understood only too well that it was Edith who stood before me – undoubtedly Edith. It was, in truth, Edith that I loved: pale Edith; fair Edith. It was Edith I loved, with the full force of my unreasonable passion! Had I been alone with her, I would have stood there stunned with amazement, beset by dreadful temptations; I would have been mad with the desire to crush her lips to mine, to drink in their moisture.

Madame de Laneuil was still laughing as she explained *her idea*. . . .

The excitation which had briefly taken hold of me abandoned me again, defeated by circumstance, and an all-too-familiar sense of desolation swept over me. But then I realised that Edith was still staring at me – and had never ceased to stare at me. Undoubtedly, Edith was staring at me.

I met her eyes with my own. My gaze was steady now. Within the space of a single instant I had contrived to replace the flare of powerful desire with a simulation of indifference, but it was too late. She understood – everything! There was a moment of mutual comprehension, which seemed to last forever, as she confessed with a flicker of her eyelids that her thoughts were in perfect harmony with. . . .

Madame de Laneuil was questioning me. "Now then, what do you think? Give us the benefit of your advice."

I took hold of myself, suppressing the unexpectedly joyous illumination which had taken hold of me as a result of my awkward discovery – but my reaction must have been visible, for she noticed the change in my attitude although she mistook its cause.

"Ah!" she exclaimed. "It has dawned on him that we are here to celebrate a wedding, not a funeral!"

Edith smiled sadly.

"Let us see what needs to be done," I said, in the businesslike fashion which the women clearly expected of me. "But if we are to make a sensible judgment, Edith must put the dress on."

"Of course! Edith, you must put the dress on."

It was my turn now to hide my eyes. I turned away discreetly, and looked out through the window-pane. . . .

The moon was high now, and the shadow of the house lay darkly upon the lawn . . . but that scene was displaced in my imagination by a very different vision which I built from the sounds I overheard: the rustling of fabric, the clicking of buttons and hooks. In my mind's eye I followed all the phases of the metamorphosis which was accomplished behind me. The sounds were instantly transposed into images by the alchemy of the senses, and I saw – literally *saw* – my loved one's throat laid bare as her deft hands pulled down her shoulder-straps. The movement of her sleeveless arms as she shrugged off her clothing released a perfume which seemed to me as sharp as the scent of the lilacs, and the curve of her breasts raised by the upper rim of her corset . . . oh, the heady scent of the lilacs! . . .

The white dress fell like an avalanche into my dream, drowning the images. . . .

Edith smiled sadly.

I hastened to play my appointed role, as couturier. I proffered my advice, and my judgment was promptly accepted. I instructed Rosa where to place her pins, and how to repair the seams, and she accepted my orders respect-fully.

Before I left the room – preceded by Madame de Laneuil, who had undertaken to show me to my bedroom – I exchanged good wishes with the young bride-to-be. We were in perfect accord, discreetly concealing the secret which we shared. Her eyes followed me as I departed . . .

the clear blue eyes which were the windows of her soul. . . .

The blackbirds had long since greeted the dawn from the leaf-laden crowns of the chestnut trees when Alberic came into my room. We talked as old friends should, about the times we had shared. Like any man about to be married he was tormented by a few lingering doubts, which he confessed to me without the slightest inhibition, taking it for granted that I would be sympathetic and supportive. I let him do it, and felt as if he were speaking on my own behalf. As proverbial wisdom tells us, it is necessary when one is in a state of desolation to take careful note of the miseries of others, that in comforting them one might find consolation for oneself.

But oh, how I yearned for the holy sacrament of a kiss from *her* lips!

Another vision, born of murmurous sound: Edith made her entrance into the morning-room, while the portraits of her ancestors looked down from the walls. Her eyes declared that she had not wept, but neither had she slept; there was a hint of hollowness beneath the pale sapphires.

Her virginal body was swathed by the bridal dress whose imperfections I had helped to correct; her face was hidden by a great white veil.

She moved slowly and self-consciously past the choir, the cynosure of all eyes, to the place where her grandfather awaited her. The old man seemed almost overcome by emotion. She passed close by me, and with only the slightest movement of her lips, her eyes lowered to signify the hopelessness of our sudden mutual realisation, she conveyed to me the briefest of messages:

"It is too late!"

I, too, lowered my eyes, hiding in the depths of my being the echoes of that joy which had flared up so urgently only to be damned.

She permitted the old man the favour of a kiss; with her hands resting on his shoulders she smiled at him.

Edith smiled – sadly.

I was very close to them. The edge of the great veil touched my head when it was momentarily inflated by the draught from an open window. It seemed to me then that a breath of passion had caught us and lifted us up, Edith and myself. . . Edith the pale; Edith the fair; *and me*. . . towards the unattainable paradise of betrayed and perjured lovers.

As she returned to her mother's side, her sad eyes lingered for a moment upon me; then, abruptly, she withdrew into the enveloping folds of the veil. She departed – forever!

The sharp and cruelly ironic scent of the lilacs drifted in through the window.

She went to be married.

During the ceremony, I responded in the silence of my heart to the priest's ritual interrogation: I do! I bowed my head when he extended his hands to receive and sanctify, in the name of Almighty God, the sacred oath of the two newlyweds.

I remembered, as I did so, the theological argument which says that in all the sacraments there is both matter and form, essence and method. I realised that in the marriage ceremony the ritual is only the form and not the matter, and that a marriage is made not by the benediction of the officiating priest but by the mutual consent of those who are espoused – that consent, and that alone, is the matter and essence of a marriage.

"Go then," I said to her, silently. "Be the wife of another, in the eyes of the world. I am refused the joy of possessing you in any sense that the world would call possession, but in truth *you belong to me*. Almighty God knows our mutual will, our mutual consent, and that is all that matters. It must suffice."

And so it was that I felt a certain bitter joy when the priest said: "Whom God has joined together, let no man put asunder. . . ."

I slipped away as stealthily as an artful thief.

The blackbirds sang no more in the leaf-laden crowns of the chestnut trees, and the sharply-scented lilac-blossoms were fading at last – were as faded now as memories of the lost passions of youth. . . .

DON JUAN'S SECRET

Devoid of soul and avid in the flesh, Don Juan prepared himself from earliest adolescence for the vocation that would make his name legendary. His cunning foresight had revealed to him the shape of things to come, and he entered upon his career armed and armoured by the motto: *To please yourself, you must take what you please from she who pleases you.*

From one of his fair-haired conquests he took a deft gesture of the hand, which echoed the painful beating of an empty heart;

From another he took an ironic fall of the eyelid, which conveyed an illusion of impertinence and which was certainly no mere reflex of a feeble eye before the light;

From another, he took the petulant stamp of her pretty and impatient foot;

From another, soft and pure, he took a smile in which he had previously seen, as if in a magical mirror, the contentment of satisfaction; and afterwards, the pleased renewal of desire;

From another, not so pure and without softness, but ever vibrantly alive and as nervous as a kitten, he took a very different smile: the kind of smile which remembered kisses strong enough to stir the heart of a virgin;

From another, he took a sigh: a deep, tremulous and timid sigh; a sigh like the hectically fluttering wings of a frightened bird in flight;

From another he took the slow and unsteady gait of one overwhelmed by an excess of love;

From another, he took the loving voice whose whispered endearments were like the weeping of angels.

From all of them he took the expressions which showed upon their faces: the gentle, the imperious, the docile, the astonished, the combative, the envious, the lovely, the

trusting, the devouring, the thunderous, and all the rest; and he built these one by one into a great garland of fascinating appearances. But the most beautiful of all expressions to Don Juan – a precious stone among countless beads of glass – was the expression of a ravished girl, hunted and caught and mortified by love and despair. That look he found so poignant that it became the motive force of his eternal search for more and more of the same wild gratification; it was the secret inspiration of his great carnal quest.

Time and time again, Don Juan triumphed over the female heart. He won hearts ingenuous and trusting, hearts tender and righteous, hearts which did not know their own secrets, hearts empty of innate desire, hearts deliciously naive; gentle seductresses and ardent seductresses all came alike to him, and were likewise beguiled.

The pattern of his seductions was always the same: his gentle touch, excused by a hint of laughter in the eye and a pleasant smile; her slow entrancement by his steady gaze; the first deep and fractured sigh wrung from his breast, accompanied by a subtly impatient tap of his foot, as if to say: "You have wounded my heart; that will not prevent me from loving you, but I am angry." Then, he would see the precious look of the hunted beast upon her face; then, he would touch her playfully with his little finger.

After a pause, he would whisper, lovingly: "How beautiful it is tonight!" – and the young lady would instantly respond: "It is my heart and soul that you want, Don Juan! So be it! Take them, I give them to you freely."

Don Juan would accept the delicious offering, and would savour all the feminine charms of the new lover: her skin; her hair; her teeth; all of her beauty and all the perfumes of her secret places – and, having enjoyed to the full the fruits of her newly-awakened love, would then depart

Around his own heart he built an inviolable shell, in which it was as comfortably encased as if it had been enshrouded in white velvet – and with that armour to protect him, bolder than any giant-killer, more revered

than the holiest of relics, he increased the number of his conquests vastly.

He took all of them: all those who might provide a new hint of pleasure, a delicate nuance of joy; he took all that he was allowed to take by those whose sisters had already given him all that he desired. His reputation went before him, and as it increased the women became all the more ready to bow down before him and kiss his hands submissively, overcome by the mere approach of their conqueror.

In the end, women competed with one another to be the first to submit to him, or to be the one who would surrender most; intoxicated by the mere thought of their impending enslavement, they would begin to die for love of him before they had even tasted his love.

Through all the towns and all the châteaux, to the remotest parts of the land, there spread the cry of the fatally enamoured: "O my love! O desire of my flesh! He is irresistible."

But the time came, as it had to do, when Don Juan grew old. His strength was sapped by his luxurious indulgence and his appetites dried up. As is the inevitable way of things, he became a shadow of his former self.

To the last flowers of summer, Don Juan had given up the last grain of his pollen; there was not a drop of sap left in him. He had loved, but now would love no more – and he lay down on his bed to await the arrival of the one who was destined to claim him.

But when that one arrived, Don Juan – still unready to accept his fate – offered to him anything that he cared to take, out of all that had been so carefully stolen from those with whom the great lover had taken his pleasure.

"I offer to you the rewards of all my seductions," said Don Juan. "To you, O Ugly One, I offer all my gestures, all my looks, all my smiles, all my divers sights – all of that, and the armour which encases my soul: take it and go! I wish to relive my life in memory, knowing as I do now that memory is the true life."

"Relive your life if you wish," said Death. "I will see you again."

And Death departed, but left behind him a host of phantoms which he had raised from the shadows.

These phantoms wore the forms of young and beautiful women, all of them naked and all incapable of speech, moving restlessly as though there were something which they were desperate to obtain. They arranged themselves in a great spiral around Don Juan's bed, and although the first of them was close enough to take his hand and place it on her breast, the last was so far away that she seemed as distant as the stars.

She who had placed his hand on her breast took back from him a deft gesture of the hand which echoed the anguish of an empty heart;

Another took back from him the ironic fall of a white eyelid;

Another took back from him the petulant stamp of her foot;

Another took back from him the subtle smile which spoke of satisfaction obtained and the renewal of desire;

Another took back from him a different smile, which reflected the pleasure of secret delights;

Another took back from him a sigh like the flutter of a frightened bird;

And then there approached another, who moved with the slow and unsteady gait of one overwhelmed by an excess of love; and another whose sad and loving whispers were like the weeping of angels; and the great garland of the expressions which he had gathered one by one – the imperious and the thunderous, the astonished and the trusting, the gentle and beguiled – all were retaken from him; and every one of those whom he had carefully violated came in her turn to take back from him her illimitably precious and fugitive expression of love and despair.

Another, finally, took from him his own heart, whose delicious innocence he had so carefully preserved within its cloak of white velvet; and then he was no longer the great Don Juan, but only a senseless phantom.

Like a rich man robbed of his wealth, or a flyer without wings, he was the merest echo of a human being, reduced to elementary truth, without his inspiration, without his secret!

THE FUGITIVES

Leave the street to those whose
souls are troubled.
Albert Samain.

"And why one," said he to himself, "when there are the others? What primitive commandment makes this one my destiny, instead of that one? I will not be the slave of a single flesh; I wish my desire to be expansive, I wish to release it to the pursuit of unknowns by routes unknown. . . ."

His diseased imagination experienced a very real suffering by virtue of the multiplicity of women. Sometimes a brain-fever of eroticism excited him to the point where he would cry out, helplessly: "There are too many of them! There are too many of them!"

He would have liked to summarise in the draught of a kiss upon a chosen set of lips the entire essence of Femininity, but the accomplishment of that Neroesque desire would have killed Desire just as surely as roses are killed by cutting down a rose-bush, just as surely as a smile is killed by cutting off a head.

As well might one hope to draw in by a single inhalation the ultimate breath of Love, the ultimate perfume of Life and all its fecundity; to master the ultimate volition of the soul and its ultimate sensuality.

These crises of unreason sometimes laid him prostrate; at such times he would laugh at his fantasy so as not to be frightened by his folly, and his licentiousness would be calmed for a while by innocent dreams. He would conclude that his lover of the moment was decidedly adorable, and that she would be the only one, the one who would be set above all others – and he would confirm it by praising to the limit, albeit with an indecisive smile, her mysterious and delicious absence of promise:

"Your magnificent stupidity," he would say to her, "makes you one with the Infinite; you fraternise with the Absolute, and the nullity which mortifies itself within your eyes, like the light of a dead star, proves to me that it is possible both to be and not to be, at one and the same time. . . .

And Nothingness has made me a soul like yours.

". . . But understand what this means: in being nothing, you are everything – and everyone."

The poor lover in question would willingly have fled out the door, but she was invariably in awe of him, and he would profit by her fear to pluck her from the rosary of the fugitives.

This was the second stage of his madness.

He would say:

"Ah! I will tell you the stories of all of those who are within you. I have seen them, I have captured them, I have placed them within you: they are the women of the street, the women who pass by, the unknowns which go by – who knows where? – who go about their business by unknown paths. They are within you, but you know nothing about them; and for myself, I know only this: were I to touch you they would free themelves from you and revert to their mysterious selves. Those who are within you are not really there: they are but a dream within a dream – but I have told you this, my darling, only out of politeness, so that there can be no legitimate excuse for you to be jealous.

"Frankly, you are actually too tiny to contain so many dreams and so many desires. Those whom I love are innumerable; I will tell you their stories:

"One has the precise and muscular gait of a huntress – what fine straight legs! She has exactly the kind of flesh necessary to preserve the harmony of her form, as supple as the branch of an ash-tree. When she swoons, as love dawns

in her, at the foot of some ancient comforting oak, in some remote forest which the sun does not dare to disturb, I am not there! I never will be there! Oh, I am mortified by desire!

"Another has such beautiful hair, which carries all the colours of the rainbow, and her belly – how I wish that she were mine! – is as white as a cloth woven out of asphodels . . . but she is no more mine than the other, and never can be!

"Green eyes . . . yes, the one which I see now has green eyes, the eyes of a succubus, the eyes of a phantom, the eyes of a stormy night . . . but I will never see them opening and raging in the dusk!

"The others . . ?

"*There are too many! It is all too much!* All those wrapped up against the cold of winter, reminiscent in all their furs of the silken-haired Mongolian goats, disquieting beasts which fascinate men! . . . All those unhooked and unbuttoned, hardly dressed at all in the summer months, their lukewarm, scented palpitating flesh! . . . It is too much! It is all too much! . . . Oh, that unfamiliar female who passes by and goes on her way, whom one might never touch – and who would surely fade away, if one could touch her; for her charm lies in being unknown and untouchable. If one were actually to take them in one's arms, one would cease to love them; one would think of others, of all the others, of the fugitives . . . always, always of others!"

While the lover wept, sad and vexed, he would continue:

"But if my dream were ever to be realised, if I had had them all, even the others, if I had drunk from the lips of the Only One all of femininity, all love and all life – there would still remain the Unattainables. There would still be Helen of Troy, there would still be Salomé, there would still be Madeleine, there would still be Ophelia – and all the others whom the poets have made eternal!"

At this the weeping and vexed lover would laugh in her turn. And the lover of infinity, the ostentatious drinker of

souls, would pacify his grandiose desires, collapsed upon the complaisant flesh of a very plain girl, who might have been anyone.

LIMPID EYES

While I was out rowing one day, I arrived at a place where I had not intended to go.

I was bound for a house where I was awaited, by a creature whose heart was set to beat faster by every far-off noise, who devoutly desired to see her swan extending its neck from the flowering rushes – but I was unfaithful.

Two eyes arrested me: eyes of a kind I had never seen before. They were half-grey and half-violet, an acute blue melting into pale amethyst. They were cold and tempting: eyes in which souls must have drowned themselves, while believing that they fell into Heaven.

It was the eyes and nothing else, for the once-beautiful palace lighted by fake torches was now no more than an elegant ruin. I saw no more there than a safe haven from the storm, a poplar bending in the wind, a sleek boat wrecked and stranded.

An arbour and a bench, a temporary repose for the morning rower: I berthed my boat and was gently welcomed, as a guest rather than a windfall. As soon as the woman with the limpid eyes appeared, I was possessed by the silent secrecy of her cold gaze, and I took my place, unexpectedly cutting short my journey, forgetful of the other, of the one whose swan would not arrive in actuality.

A charm distracted me from my former purpose – a charm so enchanting, so haunting, and so uniquely magical that I no longer remembered that I had set out with another goal in mind, and I concluded my excursion under that suburban vine, with a glass of rosé wine before me, in a businesslike manner.

There was, however, nothing more than the limpid eyes: the face was thin, faded, and worn; the body was supple enough, but like a withered willow. The only other captivating things were her aristocratic hands, long and light, with waxen fingernails,

 . . . These pale hands
 Which remembered well and were capable of all evil,

hands equally expert in caresses and crimes!

But the woman's hands were merely the consequences of her eyes; there is a necessary harmony between the organ of immediate sensation and the organ of distant sensation, and the eyes demanded my total attention, like those of a famished and jealous sphinx.

What was she, anyhow? A little more than an innkeeper's wench, or a little less? The hostess of a riverside tavern, a pleasant and discreet woman – but those eyes undoubtedly knew how to fall shut at the appropriate moment. Those icily limpid eyes were as profound and as cold in their glaucous reflections as the river Calycadnus, tomb of Frederick Barbarossa!

When she had served me, and seeing that she had crossed her arms, lazy and bored, I begged her to sit down with me. "Come closer," I said, "and look straight at me, so that I may see your eyes."

"My eyes?" she replied, as she approached me. "They are fearful!"

"Perhaps, but they are fascinating nevertheless. They are eyes which might inspire love – and then inspire more!"

"They inspire fear, and they are always fearful, my limpid eyes. It is the water: they are two drops of water captured from the river, isn't that what they say? My mother had the same eyes of water, and when she died – as soon as her heart had ceased to beat – her eyes melted like two pieces of ice, and ran along her cheeks. I saw it happen. I was very young, but I think about it every day, every morning when I set my hair. My eyes have become exactly like those of my mother, and sometimes I fear that they will suffer the same fate, while I still live, returning to the river to run beneath the rushes and over the stones. I have never dared to weep. If they were to shed tears, they would run away, my poor eyes! Once, I envied those who are able to weep – but that was a long time ago. Only

once. Ever since, I have hardened my heart so well that nothing any longer frightens or excites it – for I must hold on to my eyes. My eyes are my scarecrow, my weapon against the desire of men. Although I am ugly and old, still I might please them, for a quarter of an hour or so, when they are in their cups and have seen my hands. Often, I intervene in their quarrels and while lowering my eyes, I gently take the hand which is lifted to strike. I command obedience; they are wary of me. Sometimes, one of them kisses my fingers, trying to stir the blood in my veins and magnify my passion, but I straighten myself and lift my head, and I fix that man with my cold eyes, my eyes of water – and he lets go of my hand. I stare at him until his desire freezes within him, a mirror of his heart. As for you, when I saw you come in I knew at once that you were of a better and more brotherly kind, and I have spared you."

"No," I said, "you have not spared me. I too was afraid, but it was a strange kind of fear – because, although I was all a-tremble before your eyes, I love them."

"That is not true!" she replied, very vehemently. "No one has ever loved my eyes, nor myself. I am in disgrace because of my eyes, fled into solitude because of the one which might have made me weep had he spoken to me but a single word of love. You love my eyes, do you? Liar! Look straight into them, then, and drown your love in the depths of these two fountains of spite."

"My love can swim," I told her. "And it is you who lies. I am not the first who has been fascinated by those limpid eyes, half-grey and half-violet, those eyes into which – this was my first impression, I assure you – souls must have fallen, believing themselves to be falling into Heaven!"

"No! no!" she cried, becoming pale with anger. "Every-one knows that my eyes are the road to hell! And what is this falling into Heaven? Are men angels, that they may fall into Heaven? You are mad, my friend."

"And what about you?"

"Oh, me too, Monsieur. I am certainly mad."

And suddenly turning on her heel, she fled.

This strange conversation left me, I must admit, in a state of mind close to distress. My hand trembled when I wanted to refill my glass, and I could not do it until the second attempt, nor could I lift the glass to my lips. That remarkable woman, whose intelligence and language quite belied her social position!

The proprietor happened to come in just then, and spoke to me confidentially.

"I hope you didn't find her too tedious. It's a pity, isn't it, that she is so mad? Her companion drowned, but she was saved, several years ago. No one came to claim her, though she had money on her, and she stayed here. No one has ever recognised her. She's no trouble, in spite of what she says; she's useful to us, and we like her. We're quite accustomed by now to her eyes and her stories. Can't she talk, though! But all that stuff she told you, she must have got it from books, long ago – ideas above her station. On the other hand, she might perhaps be a lady – you never can tell."

THE SHROUD

For Alfred Vallette

The rolling waves broke upon the beach, majestically and irresistibly; seagulls danced on the wayward currents of the air.

Along the line of debris thrown up by the high tide, walking slowly, inhaling the salty odour emanating from the wrack, on the lookout for some tiny piece of wreckage left behind by the tide, something dredged up by a trick of chance from the abyssal depths. . . .

(While he wandered thus, Aubert dreamed of a gentle and soothing hand, of contemplative eyes looking into his . . .)

. . . and in the remoter depths of his inchoate vision are stranger and more intimate sexual images: melancholy sirens with breasts rounded like melons, and long, flowing hair like the seaweed which hangs from the rocks, gracefully rippling in the water . . . their teeth are as hard and white as pearls grown in oyster-shells, and their vivid blue eyes are the colour of anemones. . . .

"Ah! if only your damp tresses were wound about my knees, if I could feel the nip of your pearly teeth upon my tender flesh, if the icy coldness of your anemone eyes might transfix my heart . . . !"

(While he wandered thus, Aubert dreamed of a gentle and soothing hand, of contemplative eyes looking into his . . .)

The blackness of the stranded wrack was unexpectedly interrupted by the whiteness of a hooded cloak, spread out. . . .

From whose shoulders had it fallen?

Blonde tresses displayed themselves in luminous waves.

The seagulls were no longer playing, the waves broke on the shore in silence; the sandy beach extended as far as the eye could see, like a tedious desert.

Asleep, almost asleep in the shade of the dunes: a dress flapping in the wind; grains of windblown sand trickling over the silky fabric of an umbrella.

"It's lovely, isn't it?" she said. "And soft, as soft as the feathers of a migratory swan, so soft, so soft. . . ."

She spoke with a perceptible accent, in a silky voice, her hand resting on the slender shoulder of a little boy, who was thin and pale, and whose features had the delicate texture of porcelain.

"Isn't it, Ted?"

"Yes, sister Sarah, yes it is!" The manner of Ted's pronunciation betrayed the fact that he was English.

Sarah was English through and through, in her soul and in her blood: the soul which could be glimpsed behind the mistiness of her pale eyes; the blood whose colour showed through her translucent skin; and in the blonde hair which spread like flames among the creases of her white cloak.

It seemed that a fragment of his vision had put on flesh.

"Surely I'm dreaming!" Aubert said. "Are you an illusion? Have I embarked upon a marvellous adventure?"

Sarah was startled by his candour in speaking to her thus. She was not used to the frank expression of such sentiments. But her astonishment was pleasant: it was as if some invisible force took hold of her, pressing her down where she rested on her back. It was so utterly unexpected. She looked up, with a blank expression in her anemone eyes and a curious coolness of her bosom. All of a sudden there flared up inside her a fierce desire to be kissed by those lips: oh yes! oh yes!

She blushed.

Her dress was flapping in the wind.

"I believe," she replied haughtily, "that I am not an illusion – and I am certainly not an adventure."

"Your eyes," said Aubert, "are full of the most delicious mischief."

"My eyes? Never mind my eyes! They are as sombre as that far-off northern isle where I was born. They remind

54

me of its skies, its soil, and the sea around its shores! They are sad eyes, lit only by reflected moonlight, and perhaps a fugitive ray of the wan northern sun ... and my soul is undoubtedly the same: my soul and my eyes are twins, sharing the same dark, unfeeling nature. I fear that behind the veil of their translucency there is only emptiness – my eyes are empty, and so is my soul!"

Aubert's vision semed to flicker like a flame caught by a breath of night air.

"What can you possibly know, and what can you possibly say, about what lies behind the veil? It is Adventure – in spite of what you say, it is Adventure! Nor is it some passing fancy – some colourful dream which might be tasted briefly, like a brief immersion in a purple sea, before returning to sleep. The path of fate has brought me here, and here I am, between the blue plain and the sad forest of faded greenery. It would not matter now if one of us were to stay while the other went on; all that would matter is that every pace which separated us would measure out another beat of our hearts.

"You are busy thinking of future encounters, I suppose; you are asking yourself what tomorrow might bring, and all the tomorrows thereafter. The prospect of many pleasures extends itself before you – the nearest are doubtless the vaguest – but I am here *now*, and the present, alas, has no existence for an unquiet soul – such a soul as yours. If you could only look into my soul your eyelids would close upon that dull vision which presently afflicts you. . . .

"I have interrupted your tedium with the pleasure of surprise; you might, perhaps, consent to be distracted for just a little longer. . . ."

Aubert's vision collapsed then, as if vanquished by the cold night air.

Sarah's dress flapped in the wind, while she replied: "No, no ... I am not bored. I have a definite purpose before me: to live. As for what you call 'future encounters' – by that, I suppose you mean lovers, and all the corollary pleasures of love – I shall plunge into such encounters as

casually as I might plunge into the sea over there, whenever it pleases me. . . .

"As for the one who will swim side by side with me, through the hazardous reefs – that is already decided, whether I wish it or not . . . and I cannot be an Adventure. . . ."

She looked up at Aubert, uncertainly. His response was simple and direct: "I must bid you goodbye, then, as it is already too late – since the illusion has fled, to become one more woman among the many."

"I will be here again tomorrow," said Sarah.

She whistled. Ted responded obediently to her summons.

"Look at him," she said, "gathering seashells – such an innocent amusement, and yet so ardent. Poor Ted! Poor scholar! Poor poet! Poor innocent! He is everything . . . and yet he is nothing at all. . . ."

With the utmost compassion she studied the little man who might have been made of porcelain; his hair fell about his shoulders like withered flowers in a Chinese vase.

The sandy beach, like an infinite desert, extended its tedium and loneliness as far as the eye could see.

As Sarah had suggested – and certainly intended – Aubert returned the next day to the same spot. The seagulls were dancing lightly on the gentle air-currents.

Sarah's dress flapped in the wind.

A white butterfly alighted on her hand; she took it by the wings and slowly tore it in two. Aubert stared at her in horror – but having committed her little murder she passed her hand sensuously through her flaming tresses, entirely tranquil. Then, as if performing a ritual, she opened her arms wide as if to receive the applause of a crowd of imaginary admirers – and brought them back again to rest upon her bosom. She smiled, very sweetly.

With consummate audacity and awesome self-confidence, trembling as though with suppressed anger, she said: "Why don't you make love to me?"

Aubert shivered in his turn, as though he were some small and tremulous creature mesmerised by a snake. The delicate predator with anemone eyes drew him towards her; he was quite helpless.

They came together, and he could feel the caress of her alluring tresses against his skin, and the warmth of her perfume . . . Their lips met, open-mouthed, and he felt Sarah's teeth as they nipped his flesh . . . felt the bite of her pearl-like teeth . . .

The pathway of his desire brought Aubert to the gilded gate of ecstasy . . .

Sarah, perfectly in control of herself, addressed him in a regal manner, and he heard her haughty words as though in a dream: "Aubert, I give myself to you. Never forget that you also belong to me. I must go; it is over, for now. I must go, but you have my word that I will return."

The sandy beach, like an infinite desert, extended its tedium and loneliness as far as the eye could see.

Asleep, almost asleep in the shade of the dunes: there is no dress flapping in the wind. Amid the blackness of the stranded wrack a dream lay dead: a dream as white as the death of a seagull.

The seagulls play, and then play no more. The steamships come into dock, smoke curling upwards from their funnels, the quays are bustling with activity. The seagulls play, and then play no more . . . the melancholy seagulls of the Zuider Zee.

Down there, in the deserted sands, no dress is flapping in the wind.

Swans flock about a galley as if it were their mothership, wings fluttering like the dead leaves whirled about the desolate headlands. The swans ride slowly on the winds, like stately sailing-ships . . . the melancholy swans of Bruges.

Down there, in the emptiness which extends to the horizon, no dress is flapping in the wind.

The sparrows chatter in the trees denuded of their leaves. Beneath the turbulent sky, lanterns flicker, more hesitant than hearts in the fog of forgetfulness, the lanterns of melancholy boats on the Seine.

Oh, how cold and lonely it is down there, where no dress is flapping in the wind!

Asleep, almost asleep in the shade of the dunes.

Amid the blackness of the stranded wrack, a dream plays: a dream as white as the awakening of a seagull – but there is no dress flapping in the wind.

Ted amused himself, as before, collecting pebbles and seashells. Sarah was smiling, and her blonde hair spread out like flames upon the creases of her white cloak.

"You see," she said. "I have kept my word. And you too have kept faith."

"Yes," Aubert replied. "But what happened between us is all in the past now."

"That does not mean that it is dead. I still love you. That which is in the past was written in the sand and in my flesh, in my hands and in my eyes, on that day when you played hide-and-seek with me: that day when your false vision excited my curiosity. . . ."

The waves thrown up by the sea came almost to the place where they walked, abandoning flotsam at their feet.

"That's enough!" said Aubert. "Ted wrote to me, as you instructed him, to tell me that you are married. What is your name now?"

"My name is Widow."

"I don't understand."

"He has not touched me," she replied, loftily. "He is a very *mature* young man – oh, so lifeless, so lacklustre! – who merely sought to complete his stable with a particularly handsome horse. He has not laid a finger on me . . . that makes you smile, does it? You may sniff at it, but it is true. If it were otherwise, I might need to ask forgiveness."

"But you do not ask for forgiveness?"

"No."

"You have no pity to spare for me."

"Pity is pointless," Sarah told him, "more pointless even than life itself . . . what happens, happens, and that is all, until one reaches the final judgment – without ever understanding."

"Without ever understanding?" Aubert echoed.

"Be quiet and listen. I want to tell you the whole truth."

"No. I don't want to hear it."

"You must," Sarah insisted. "I had already consented to endure this marriage when I met you. I had not protested previously, but afterwards, I did – but I had to go through with it, because I was under an obligation to my family. Can you understand that? It is you I love, you I want . . . and so I have followed the dictates of my desire. . . ."

The waves thrown up by the sea came almost to the place where they walked, abandoning flotsam at their feet.

They looked at one another helplessly, their eyes heavy with disquiet. Aubert, in a cruelly ironic voice, demanded: "How is it that you are not still in his grasp?"

She sighed. "I have drowned him in sarcasm."

"Is he poisoned?"

"The dosage was adequate."

"Let us be clear about this," Aubert said. "You have killed him?"

"Yes, for you," she replied. "But do you still want me?"

He did not reply, but he walked on with her along the line of the incoming waves . . .

. . . Walking slowly, inhaling the salty odour emanating from the wrack, on the lookout for some tiny piece of wreckage which might at any moment be cast up by the tide: something dredged up by a trick of chance from the abyssal depths . . .

Sarah followed him, poking at pieces of dead seaweed with the tip of her furled umbrella.

They went a long way in silence. The retreating sea became calmer – and Sarah's dress was flapping in the wind.

Aubert suddenly stopped and turned to face her. She was following close behind, and the great white hood of her cloak, trimmed with swansdown, sat upon her shivering shoulders like the hood of a carriage . . . it was as if she herself were a migratory swan, her down so soft, so soft! . . .

He snatched the cloak violently from her shoulders, and threw it into the sea, saying: "Let the sea carry it away! Oh − it is too late! If only it had carried you away, that first time!"

Sarah, alarmed, crossed her arms in front of her − but Aubert took her hands in his and she read in his eyes that he had forgiven her for what she had done . . .

After all, as he had said to her, the moment had to be seized, had it not?

She did feel pity for him, then; she was cold, and she became sharply aware of the coldness in her soul. Aubert was overcome by a tremulous wave of emotion, and did not try to shrug it off.

The sea reached out to the place where they stood, casting its ebbing waves at their feet.

Sarah stood silently before him, sick at heart. She felt bile rising up from her stomach, bringing a bitter taste into her mouth, where her teeth were chattering like a chaplet of pearls in the playful hands of a little child. Her hardened tongue was paralysed, as if numbed by poison.

Side by side, they followed the ebb of the tide. Aubert fixed his eyes upon a particular piece of flotsam which the sea turned over and over, folding and unfolding with the rise and fall of every rolling wave.

They went on and on, with Sarah's dress flapping in the wind.

They continued to follow the outgoing tide, until the first shoals of rocks emerged, like eternal shipwrecks, from the grey-green swell; the white cloak had disappeared, ensnared by the black tresses of the dead seaweed.

"It's gone," said Aubert. "Let's go back."

But he made no move; they both stood still, facing the

roiling sea, while the waves broke against the rocks, as though they were lost in a dream. Aubert stood with his hands clasped behind his neck, as if his arms were a yoke. Sarah's spirits revived. She was sure of him now: sure of his acceptance, sure of the love of which his tightly-compressed lips – more than a little ashamed – silently spoke. Those beloved lips were hers after all

Her dress was rustling in the wind.

"I have a life to live!" she cried.

"Never forget," said Aubert, "that your life belongs to me."

"And your heart to me, my darling."

A wave unlike the others broke at their feet.

"The sea refuses it," cried Sarah. "The sea refuses it, but as for me – I want it!"

Triumphantly, with her flaming mane billowing in the wind, she threw herself upon the wreck which fate had cast at her feet. She wrung the water out of it and held it aloft, saying: "Behold the shroud of a survivor!"

Her dress was flapping in the wind.

ON THE THRESHOLD

In Gallows-Tree House, everything was sad and grandiose. Its name immediately brought to mind the primitive cruelties of feudal justice; its four dark avenues echoed with an ocean-swell of lamentations; black swans swam among the broken reeds of its moat; menacing hemlocks and a host of yellow flowers opened their petals like deadly suns.

The house itself had walls the colour of a stormy sky, a roof creased by grooves like a ploughed field, arched and narrow trifoliate windows. Its tower was discrowned, having fallen prey to a formidable ivy which clung to it with the perpetual tenacity of life.

Having climbed the steps and entered by the great door, one passed into its vast rooms, high-ceilinged and cold, decorated with oak panelling intricately carved with all manner of verdure. There one could see all over again the languid reeds of the moat, its gloomy flowers and hemlocks, sheltering with their icy shadow the regal walk of the dispirited swans. There were no carpets, only mats of straw; dogs slept here and there, with their noses between their paws.

There was also a most curious spectre to which I had never really become accustomed: a tame heron, which roamed freely between the rooms, rapping with its beak until the doors were opened.

This funereal creature was always present; it followed us in to every meal, foraging in the bowl where its food was thrown. At regular intervals it made a clicking noise like a loose tile blown across a roof by the wind. It was called "the Missionary", because it resembled, by virtue of its oblique and paternal expression, a certain Capuchin friar who had come to say mass in the house – and whose death, which followed unexpectedly a few days after, had coincided with the appearance of the bird. It had been found on the moat by a gamekeeper, wounded by a rifle-shot.

The slightly ridiculous story of the bird had amused me when my host told it to me on the first evening I passed at Gallows-Tree House, even though there was no hint of jocularity in his tone. On the following day, however, I began to find the Missionary unsettling, not so much by virtue of its ugliness as by virtue of its assurance – the certainty with which, it seemed, the creature made itself at home, as if it were the mistress of the household or if it really had come in to accomplish some supernatural mission. No one ever scolded it, no one ever shut it in; as soon as its beak clattered against a door, someone got up to open it, and if all of us went out together, the bird would pass through at the head of the company, with the solemn air of one no less important than the Capuchin, as incorruptible and as gently pitiless as an ancient judge.

Privately, I gave this "Missionary" another name: Remorse.

One evening, when we had got up from the table, having dined on venison while supping cider perfumed with juniper, I ran into the bird near the door. Impatiently I said to it, under my breath: "Go on then, Remorse!"

"Why do you not call him the Missionary?" the Marquis de la Hogue demanded brusquely of me, seizing me by the arm. He was staring at me with eyes animated by an emotion that I believed at first to be anger, but which was actually terror.

He added in a tremulous voice which broke upon the words, as if to reveal, in spite of his best efforts, some secret: "How did you know that he is called Remorse? Who told you that?"

And it was by virtue of that one word, which I happened to let fall because I was nearly as troubled in my own mind as Monsieur de la Hogue, that I assured myself of being taken into his closest confidence.

When we entered the room where we talked in the evenings, the bird was standing on one leg before the fireplace, its beak beneath its wing, basking in the heat of the burning logs. I sat down in a wooden armchair like a

cathedral stall. In order to resume the conversation, I said, "Is it asleep?"

"It never sleeps!" replied Monsieur de la Hogue – and, indeed, I perceived the coldly ironic eye of the ancient judge, incorruptible and gently pitiless, fixed upon me. It held a glimmer fiercer than the light of the hearth, like the dim sparkle of a star reflected in a frog-pond.

"It never sleeps," Monsieur de la Hogue went on. "Nor do I, any longer. My heart, at least, never sleeps. I am familiar with drowsiness, but I am a stranger to unconsciousness. My dreams are simply the continuation of my waking thoughts, and in the morning my thoughts take up the thread again so naturally that I do not remember having ceased to dwell in full intellectual clarity for a single hour in thirty years. And what do I dream about in this fashion, during all the interminable hours of my life? Of nothing – or rather of negations; of that which I have not done, that which I will not do, that which I could not do, even if my youth were given back to me. For that is my nature; I am one who has never been active, who has never lifted a finger in order to accomplish a desire or a duty. I am a lake unrippled by any wind, a forest undisturbed by any sound, a sky untroubled by any hurrying cloud."

He fell silent for a few moments after this somewhat solemn declamation, then continued: "Do you know my life-story? No, you are too young – and in any case, what the world knows about me is not the real me. I have never told my own story, and were it not for that whim of chance or providential perspicacity which led you just now to pronounce a word – a name! – which admittedly frightened me, I would reveal no more to you this evening than I have ever revealed to anyone else. Here, though, is my confession.

"I was but eight years old when my mother brought back from a journey in distant parts a little girl, who was about the same age as myself. She was our cousin, at least

in name, and the death of her parents had left her as perilously alone in the world as a she-lamb lost at night in a wood. This adorable child was spoiled by everyone, looked upon as an ideal little sister for me, who would perhaps in time be an obvious fiancée: an angel fallen from the stars, for my eternal consolation.

"By the time I was twelve years old, with the precocious heart of a vigorous boy grown up among farming folk, I already loved Nigelle with a passion so infinite that it had neither the power to increase nor to decrease, until the day when I lost it forever. She loved me too, with equal ardour; I knew that, and the avowal of her love that she made me when she was dying taught me nothing but the extent of my own wickedness.

"As soon as a certain power of reason was granted to my childish brain I conceived an attitude to life which was peculiar and – as I think now – criminal. One day I plucked a rose, whose piquant perfume had caught me up and whose crimson smile had filled me with the desire to make it my own. But when I had wandered for a while along the garden paths, with my plucked and forgotten rose clutched between my fingers, I saw that in less than an hour it had completely faded and withered away, sorely wounded by the shafts of the sunlight – and I came to the conclusion that no matter how much one desires roses, one must not pluck them.

"And when Nigelle appeared before me, I extrapolated my conclusion: no matter how much one desires women, one must not pluck them.

"Many ideas besieged my consciousness in the train of that primordial discovery. By slow degrees, a whole philosophy of life emerged: an entire nirvanic religion was elaborated within my vainglorious and feeble head. One day, I was able to summarise it in a single phrase:

"*One must remain on the threshold.*

"A few books had assisted me – certain ascetic writings, a summary of Plato, digests of German metaphysics – but for all practical purposes my doctrine was my own. I

became very proud of it and I resolutely set forth into the darkness of inaction.

"I determined to consummate none but the simplest of acts, restricting myself rigorously to those which, because they promised me no exceptional pleasure, could not in any way let me down. I had violent desires; I indulged them; I revelled in them; I gorged myself upon them. My heart expanded to the point of containing the world. Desiring everything, I had everything; but I did not possess it in the same fashion as one who held between his own hands the two little trembling hands of another. I took everything, but nothing was given to me; I had everything – but all without love!

"Not until much later, at a certain solemn moment, did I come to understand the real meaning of love. Before that moment, my vanity had given me the illusion of love and I was perfectly happy, proud to have escaped the disenchantment which was born in every accomplished act. But even on that day, even now that I know the truth, having been instructed by pain, it would have been impossible for me to pluck the rose. What good would it have done?

"This frightful refrain resounds ceaselessly within my head, and it has never been more insistent than now.

"Nigelle and I lived side by side for twenty years. Every day she became sadder and more timorous, intimidated by my fortune, the poor soul who possessed nothing but the ripe harvest of her blonde hair. And I, meanwhile, became more and more arrogant and indestructibly mute.

"I loved her as much as it is possible to love, but I took my love no further than the threshold.

"That threshold I never crossed; neither did my shadow, nor even the shadow of my heart, ever walk in the palace of love.

"Hospitable and loving, that door was always open – but I turned my head aside when I passed it by, in order to contemplate my own desire, in order to speak with my own desire, in order to commit to the asylum of my desire those dreams that I wished to leave unrealised.

"Cross the threshold? And what then? That palace was probably no more than one of many – but the palace of my dreams was unique, and once having dwelt therein, no one could any longer see the others.

"She died for love of me – of me, who loved her with a passion that I still do not hesitate to call infinite. She died saying to me: I love you! But I made no reply."

The heron changed its feet, and clacked its beak in passing it from the left wing to the right wing; its bleak and ironic eye now stared at Monsieur de la Hogue.

"You think," my host continued, "that bird is rather ugly and rather ridiculous, don't you?"

"Rather dismal, that is all."

"Ridiculous and dismal. I support it as a kind of penance. It frightens me, and it makes me suffer, and that is what I require of it. You must understand that if it pleased me to wring its neck, I would very speedily do so!"

"Do you really think so?" said I. "Wring the neck of Remorse?"

"I have considered it," replied Monsieur de la Hogue. "But what good would it do? There is no significance at all in that ridiculous and dismal creature that I have not given to it voluntarily. I have only to renounce it for it to be as inert as any stuffed bird. Do you take me for a helpless victim of its inanity? Do you take me for a fool?"

The old man got up, shook the long grey hair which ran over his pale and wrinkled cheeks; then, abruptly becoming calm, he let himself fall again into his armchair.

He repeated, very softly and with a hint of mockery: "I suppose that you don't take me for a fool?"

As I looked back at him I smiled, and mechanically extended my hand towards the plumage of the immobile bird – but he started to his feet again, saying: "Do not touch the Missionary!"

He pronounced these words in the voice which Charles I might have used in saying to that indiscreet person as he mounted the scaffold: "Do not touch the axe!"

THE RED MARGUERITE

There was nothing remarkable about Madame de Troène save that she seemed calmly unconscious of the beauty of her face, which she conserved by her own efforts, without any other aids but pure water, unscented soap and the humblest eaux de lavender. It seemed probable that, although she was approaching forty years of age, her body had retained its symmetry and was possessed of a mature beauty, but it was certain that no one knew for sure; no one had ever made the effort to trace the fleshly contours which were concealed by her black gowns and her beaded mantles. She was quite unfamiliar with the form of her own body, because her modesty was so complete that she would not undress to get into the bath unless the shutters were firmly closed, and she changed her undergarments with all the delicacy demanded by those good spirits which stand guard over the chambers of women who have renounced all indecent curiosity.

She had been married when she was very young, more than twenty years before, to the Marquis de Troène, who, respectful of the temple of her virtue, had scarcely ventured a few trembling steps towards the virginal mysteries of the sacred wood. The marquis was so ancient and so lacking in strength that when he went to church he required the support of an assistant arm to kneel down and to get up again – but he had been so very rich, and of such a noble family, that no one had been surprised by their union. Such marriages were frequent among the landed aristocracy; they were the means by which a legal dispute might be settled, a lost domain restored, a life of ease secured, the esteem of humble folk regained, the tolerance of creditors extended again to those fallen on hard times; they were, in short, the means by which an old and faded coat of arms might recover the glitter of gilt and the brightness of colour. In any case, the Marquis de Troène was quite

harmless, and he died soon afterwards, having enjoyed for a few precious years the luminous smiles of his young wife.

He died, leaving her heiress to his entire fortune.

Madame de Troène was then twenty-six years old. The constant attendance of the old man upon her had made her so indolent, and had so deadened her spirit that she was afterwards quite content with the hypocritical attentions of her family. She refused to remarry.

Years went by while she was queen of her petty empire: spoiled, courted, and amused by the clamour with which she surrounded herself. She lived without joy, but without any sense of loss. Marriage had revealed nothing to her which might have troubled her subsequent dreams. She had no capacity to imagine anything beyond the limited role which had been assigned to her by her impotent husband: warming the bed of her lord and master, being perfectly obedient, smiling much and saying little. She understood, of course, that she might have enjoyed a more agreeable relationship with a younger husband – a relationship which would have permitted gaiety, laughter, activity, journeys abroad – but her emotional life had been stillborn; no sensation ever troubled her quietude, and her heart was quite cold.

When the marquise was thirty-five years old, however, she suddenly began to feel the burning caress of some tiny internal flame. It first afflicted her one autumn morning, on a Sunday, while she was going to mass. She was due to take communion that day, but found that she had not the strength to do so – or, at any rate, she *dared* not do so. She remained on her seigneurial bench, while all the other women, hooded in white silk with their ruddy hands crossed before their bellies, filed towards the altar, and came back again with their eyes dutifully lowered, taking great care to deaden the sound of their shoes on the flagstones. Madame de Troène remained kneeling, with her head in her hands, and she wept.

It was the first time in her life that she had ever wept. From that moment on, her character changed. Her

family became, little by little, a matter of utter indifference to her; she shut herself up for months on end in the Château de Troène, seeing no one. She did not open her letters, nor did she write any of her own; she spent her time reading devotional texts. Before very long, she placed herself entirely in the hands of her parish priest, a man both scrupulous and wise: one of those to whom bishops invariably delegate parishes where there are rich widows who might otherwise put their fortunes to no good use.

In the course of the next three years the church was restored; the presbytery was reconstructed and enriched by a beautiful meadow full of fat cows; the cupboards and the drawers of the sacristy were filled up with regal copes, embroidered chasubles as marvellous as any seen in the cathedrals; and there was displayed, in a carved cedar-wood case, a massive golden chalice whose sides were decorated in relief with a dozen kneeling angels, each one offering to the lamb in outstretched arms one of the twelve liturgical tablets, every one of which was a gem: an amethyst or a sapphire, a diamond or a sardonyx as large as a hazelnut.

Then, when the glory of God had been properly provided for, grand feasts were once again held at the Château de Troène and the members of the family of the benefactress, who numbered more than thirty were reassembled there and reunited. To be a member of such a crowd as that is not to be far removed from solitude; the freedom of everyone is assured by the freedom to which everyone else lays claim. Cliques form and intimacies develop. Madame de Troène especially welcomed the attentions of young Jean de Néville, a handsome and sober adolescent who was quick to fetch her folding-chair when they went for a walk in the park, and was never slow to slide a cushion under her feet – who pandered to her every whim, in fact, with an affectionate good grace.

He did not address her as "aunt", after the Breton fashion, nor "cousin", in the Norman way; he displayed a

finer sense of etiquette by calling her "Madame", as if he were her page.

Young Jean de Néville was passionately interested in stories and legends of the family. Madame de Troène told him several of those which had been told to her when she was a child, which seemed to her to be mere fables, but when Jean raised the subject of the "red marguerite" she did not know what he meant.

"But it is the most famous legend of the Diercourts," Jean told her, "from which you are directly descended by the female line. I too am of that line," he added, proudly, "and I would dearly like to tell you the story."

"Tell me then, my page."

"It happened in the time when the inquisitor Sprenger was burning witches in Germany. Catherine de Diercourt, the wife of an army commander who was at that time away on active service, was thrown into prison – not as a witch, exactly, but as one who had protected witches. Like all the others, she was stripped naked and put to the torture. As soon as the wooden boot, pressed by a powerful vice, had closed upon her leg, she confessed everything which was demanded of her. She was condemned to be burnt at the stake – but then, she declared that she was pregnant.

"Sprenger ordered a postponement of her execution, but because she was destined for the fire, she was marked with the sign of the 'consecrated'. This took the form of a kind of marguerite with thirteen petals, which was imprinted with a red-hot iron beneath her right breast.

"Catherine de Diercourt had told the truth. She was eventually brought to childbed while she languished in prison; and she was burnt at the stake three weeks later. Sixty of her compatriots were likewise executed.

"The child, which was a girl, was eventually delivered to the care of Monsieur de Diercourt. It was found that the stigma had mysteriously passed from the mother to the daughter: the daughter, also named Catherine, was marked beneath her breast by the dreadful red flower.

"And that," continued Jean de Néville, "was the origin of the legend. It is said that to this very day, all the women of the Diercourt line – all the blood descendants of the protectress of witches – are marked indelibly by their heredity, by that same mark beneath the same breast. It is also said of them that they can only love once, and be loved once; and that those whom they love, and those who love them, are 'the consecrated': doomed to an early death. I have researched the history of several families into which the descendants of Catherine de Diercourt married, and . . . well, there seems to be some truth in it!"

"What a strange tale!" said Madame de Troène, forcing herself to laugh. "That one was never told to me, not even by my mother – but I am certain that I . . . that mark . . . I do not have it . . . but then, I have never looked! For shame! How can one stand before a mirror, to look at one's naked self? How can one be so immodest as to stand naked before that other woman . . . that ironic reflection, which stares at one, and smiles at one so sordidly? I would be ashamed to do it!"

Jean de Néville, with a blush upon his cheeks and his breathing slightly heightened, his beautiful eyes wide open and slightly moist, shook his wrists. His cuffs were decorated with skeins of silk-like little chains, which had become entangled. All at once – after a momentary silence; a terrible silence during which the marquise and the adolescent page were brushed by the invisible caresses of ideas and images – all at once, Mme de Troène bent her head towards Jean, who was kneeling at her feet. Placing her hands on the youth's shoulders, she kissed him on the mouth.

When they finally rose to their feet again, initiates in a new mystery, the shades of night were falling and the lamps were being carried to their stations. Madame de Troène shivered deliciously; she looked at Jean, who was quite pale and slightly dishevelled. They could find nothing to say to one another; they were submerged beneath the surface of oceanic emotions.

In the end, exhausted by delight, she murmured: "Go away!"

The next morning, Madame de Troène appeared so discomposed, and in such a state of disarray, that everyone was anxious. She tendered some excuse for her malaise, but as soon as she was alone with Jean, she touched a finger to her bodice and said: "The red marguerite! I have it, the red marguerite!"

"So much the better!" said Jean, with all the simplicity and the nobility of a heroic lover. "I love you so much that I fully desire to die of your love."

Afterwards, during the dark and silent nights of joy which were given to them, Jean searched with his hand for the stigma, no longer the symbol of those 'consecrated' to the stake, but the sign which nevertheless consecrated him to death. One evening, when Madame de Troène permitted that a candle should remain lit, Jean saw the sign – and, with a strange frenzy and a precocious perversity, he kissed it over and over again, tirelessly, until morning came: the diabolical red marguerite.

The affair lasted two months. Jean had to leave in order to return to his studies, for his last year of college. He promised to write, but no letter came; she wrote to him, discreetly, but he did not respond.

When she went to see him, finally, she found him dying. His life had faded away, and his memory too. He was dying of his two months of love; dying of having loved the red marguerite!

Madame de Troène dressed in mourning and proudly – without deigning to reply to any questions – maintained herself thus until his death, which was not long delayed. She was no longer a votary, but never ceased to be religious. Now, though, her religion had something wild about it. She became a martyr; once, she remained on her knees in church for eight successive hours, without bestirring herself any more than the stone image of St John, upon which she fixed her ecstatic eyes. She subjected herself to fasts which would have intimidated anchorites.

It took her three years to destroy herself.

Because, in spite of her evident piety, she never went to confession, the curé came one day to interrogate her. She replied obdurately, as though recovering at a stroke all the insolence of the Diercourt women, and their hatred for the Church: "Monsieur, the secrets of a Marquise de Troène are to be revealed only to God."

During her death-agony, when the priest redoubled his objurgations, she still remained mute – and she died, draped as though by a shroud in the impertinence of her absolute silence.

She died with her finger delicately placed upon her secret, upon the one unforgettable interval of human joy which the Evil One had vouchsafed to her: upon the red marguerite.

SYLVIE'S SISTER

Madame de Maupertuis crossed the courtyard and, opening a little lattice-work gate, entered the garden.

As she went hither and yon along the pathways, the tight white dress which she wore, made of light jaconet, outlined by its movements the delicacy of her figure. A pink ribbon fluttered behind her. Her throat, partly exposed by the low-cut dress, was modestly screened by a sash worn according to the new fashion, coloured red, yellow and blue. She was bareheaded; her blonde hair was coiffed in the Greek style, gathered up from her neck to make a frame for her forehead, curling a little between the eye and the ear. She was handsome, in spite of the fact that an unusual pallor had displaced the usual rosiness of her complexion, and that her blue eyes were narrowed and her nostrils pinched – the consequences of her long vigils in a sick-room.

Leaning his elbows on the wall which enclosed the garden, looking out over the steep slope which fell to the highway, Monsieur de Maupertuis was lost in thought. His eyes roamed the distant meadows full of willows, and the circling hills crowded with beeches which extended to the horizon. He was facing the setting sun, which slowly descended behind the trees; a great wave of light, rolling under the green arches, came forth to bathe the white road; the meadows were falling asleep in the humid dusk and a mist was already beginning to rise, its inconsistent contours following the winding course of a brook, from which birdsong arose as all other sounds died away.

Such scenes as this, and similar evening displays, Monsieur de Maupertuis remembered having seen in England, when he was a child, during the sad exile which had been forced upon him. Suddenly he seemed to see once more in the middle distance the unfortunate manor-house of Watering-Hill, where he had once assisted, on just such an

evening as this, in making the arrangements following the tragic death of Lord Romsdale. The name of Romsdale, whose syllables he had murmured aloud, evoked further memories, and his reverie became even more profound.

His wife's little hand was suddenly placed on his shoulder.

"Adelaide! You startled me."

He was actually trembling. Adelaide put both her arms around his neck and gently kissed his forehead; his eyes became illuminated by a flame of love. Adelaide looked at her husband for a moment, wearing an uncertain smile, before confiding in him.

"Patrice," she said, "my sister would like to speak to you, alone. She insists on it. She desires a moment of privacy with you."

"A mere caprice of the dying," said Patrice, letting her lead him away. "What could she possibly have to say to me that she could not have said to her confessor, or to you?"

Monsieur de Maupertuis entered the sick-room, his heart clutched by the odour of death which floated around the bed. A little hand extended from the bedclothes, as thin as an autumn leaf and almost as translucent; he took it in his own as he knelt down and, in spite of his repugnance, lifted it to his lips.

Upon the huge bed, the slight consumptive form had hardly more presence than a rag doll. The head sunk among the pillows stood out against the cambric, the colour of wax against the stark white. Two black eyebrows traced a heraldic design upon the frail profile, converging above the bridge of the Bourbon nose; the eyelashes resembled the little fine darts detailed in icons, and when she opened her eyes, it was the darkness of night which could be seen therein. Her brown hair had been tucked into a lace bonnet, but a few trailing locks dangled upon her forehead, curling inconsequentially across the wrinkles and ragged furrows which creased it.

Moving herself with evident effort, the dying girl

reached beneath the mattress to bring forth a moderately large portfolio bound in faded and crumpled velvet. A cordlet of gold thread secured it; embroidered on the cover in yellow silk, at a place where the velvet was neatly shaved in a diamond-shape, two lines were thus inscribed:

$$SYL =$$
$$= VIE$$

Monsieur de Maupertuis looked at the portfolio, and his eyes met Sylvie's. So mournful but a moment before, hers had now became animated by a glimmer of light, which seemed to him somehow perverse and hypocritical. There arose in him a defiance against whatever was to follow; he could not help it, although he had a dutiful respect for the dying.

"Patrice," she whispered, "this will explain it to you – but listen! Do not judge Adelaide as severely as you would judge a man. Women do not have a proper sense of honour; for them, emotions come before everything else. Be . . . therefore . . . indulgent . . . Patrice . . ."

A fit of coughing overtook her. She breathed, then began again: "Lord Romsdale. . . ."

But these were her last words. Another spasm took hold of her; blood mingled with saliva ran from the corner of her mouth, and she fell back heavily upon the pillow. She was dead.

Until the eventual arrival of Adelaide, Patrice remained fascinated by the eyes of the corpse: by those perverse and hypocritical eyes.

Monsieur de Maupertuis already knew the story. What could be more banal? A marriage which had not in the end been made – about which Adelaide had had her regrets, and her chagrin, perhaps even a momentary despair. She had told him all about it herself, with a frankness which appeared total. The letters, to be sure, were a little vivid, almost disquieting, but . . .

One evening, when the lamps were lit, he said to his

wife, while placing before her the pink velvet portfolio, "Adelaide, this was Sylvie's secret. Oh, your sister has been quite devilish! I can only suppose that you gave these letters to her so that she might burn them, having not had the strength of purpose to do it yourself . . ."

"What letters?" asked Adelaide.

"The account of a passion."

"I don't understand."

"They concern a family who were our benefactors. The father liked me very much; the son . . ."

"Young Lord Romsdale?"

"You have forgotten him, then? Here is something which will refresh your memory."

"These letters, as you say, ought to have been burnt," said Adelaide, coldly.

"That can still be done," said Patrice, "but it is in your hands . . . here is the first of them – take it, read it, and then burn it, if you will."

Oh, the memory of one's first love! The beautiful tied-back hair and the ruddily healthy cheeks of the young Romsdale! Quelling a delicious surge of emotion, Adelaide took the letter in her fingertips, and read it. She had been pale, but now her cheeks recovered their colour. Oh, the joy she once had in receiving that impassioned note!

She reread all the letters, one by one, as Patrice passed them to her – and burned them all, one by one.

When it was all over, Patrice said: "Adelaide, your sister was a wretch . . ."

"No," Adelaide interrupted him. "She was simply jealous. She became determined to love Lord Romsdale as soon as she realised that he loved me; and when you fell in love with me, she was equally determined to love you – and to hate me. No one ever realised it. If her secret has not died with her, it is only because her last act has declared all her passion, love, hate and jealousy, because death demands truth at last . . . Yes, death demands truth, and Sylvie has met that demand."

"Instead of modifying souls, death affirms them," agreed

Patrice. "Sylvie was a dissimulator and a liar. I have no reproach to make to you. You were but a child. . . ."

"Oh yes, Patrice," she cried, rising from her seat and throwing herself, sobbing, into the arms of her husband, "I was a child, a child, a child . . . !"

That evening their love was reignited. The calm tenderness into which they had fallen discovered a new incentive for excitement, and they went to the seaside, to stay in an old cottage near the beach, black and bare, where they tasted all the sensual delights. They had no obligations but to be together, and being together was sufficient reason to live. They enjoyed an ideal month of renewal, better even than the first flow of their love, for they now had a more profound understanding of themselves, and a fuller knowledge of the value of pleasure.

Eventually, though, their mutual adoration became too much, and Adelaide became listless.

"No more emotional excitement!" the doctor commanded.

"All very well, doctor," said Patrice, "but how can one live without emotion?"

They had reached the limit. The last roses had bloomed and a single gust of wind would clear the flowerbed. Patrice thought his wife's weakness was a transitory crisis, but Adelaide could not bring herself out of it, except to die.

But before she died, the sister — Sylvie's sister indeed! — drew the ear of her husband close to her lips, and in a whisper which might have come from the infernal depths — a whisper which trembled with the force of her supreme deception — said: "Patrice, I die loving Romsdale!"

THE OTHER

She went to bed as obediently as a child, promising to be thoroughly sensible, to sleep and not to daydream. In order to soothe the fever of her sick headache, and make her more tranquil, she had been assured that it would soon be over: the vile sickness would be conquered and dispatched, and would not be the death of her.

Her illness took the form of a crippling lassitude; it drained all her strength and sapped all the power of her life and will. She sank into it as though into an over-warm and overly-prolonged bath, enervated to the point of discomfort but troubled by a restlessness which would not allow her to be entirely still. Her mind was similarly afflicted by the combination of dullness and agitation. She was beset by desire but found nothing to appease it; she wept over her distress, and tried in vain to console herself with the fancies of her impuissant imagination. One thing only could excite her heart with passion: the entrance of her husband immediately caused her to lift her head; one tender word from him, and her eyes lighted up; at his caress, her entire being thrilled, momentarily galvanised. In the presence of her husband, a slight pinkness animated her cheeks; her hands recovered the power to make graceful gestures; her lips had the strength, if only for a second, to meet his adored lips.

Her body seemed to her to be quite translucent, like an abandoned seashell which, if placed in the sun, would be penetrated by its light and made iridescent, like a pearl mislaid in the sand. To the melancholy eyes which contemplated her, she thought, she must resemble a precious jewel-case which had no more glory left than its intricately-carved wood, its brasswork tracery, its ornamental lock, its vermilion inlay and its nails; all the interior treasure had vanished, alas.

So she went to bed – and at first, as she had promised,

she made an earnest effort to sleep profoundly. Soon, however, as time went by, her dreams drifted up towards consciousness as though they came to float on the surface of a lake, like some heavy log of wood which had in the end to submit to the law of nature, consenting to float and follow the tide. Her reawakened mind sailed away, inexorably drawn by a secret current which left the surface of the water undisturbed. She sailed on, and dreamed with closed eyes, without making a movement, without in the least disturbing the rhythm of her breathing, so that any observer might believe that she still slumbered at the bottom of the lake – thus ensuring that the observer would be pleased with her, and that she would not be scolded.

She had become so childish since being stricken by her malady, like a little girl before her first communion, so very docile! Not long ago she had been imperious and forceful, a woman whose advice was heeded – even, on occasion, a tyrannical mistress. Now she was as mild as a desireless virgin. The only joy left to her was to shut her eyes, to be surrounded by silence, and to dream.

She usually dreamed of old times: of the first kisses which had revealed to her the commanding power of love and taught her how agreeable contact with that dangerous creature *man* could be. She would dwell indefatigably among memories of her initiation, taking care to recall every single word and every single gesture of her lover, and the precise colour and the exact perfume of the first flowers which he had placed at her feet. When she arrived again, in due course, at the supreme and adorable night, she sometimes let loose a faint cry which disturbed the house – but anyone who came in would find her hypocritically calm, making believe that she was asleep despite that her respiration would be a little hasty, and that an unwonted redness would lie upon her pale cheeks.

On this particular evening she slept unusually well, but her dreams were bad.

This time, her memories were not extended in a rationally ordered fashion. Her imagination was overpowered,

and the images which she conjured up for herself vanished in an instant, to leave her with nothing but a haunting and grotesque vision of a woman whose face was veiled by a handkerchief, and whose dress was lifted up by a brutal hand. All night, that ignominious vision danced beneath her eyelids, and the spectacle filled her, simultaneously, with a profound disgust and an impotent anger. These emotions exhausted her, overwhelming her fragile vitality.

Next morning, the dream vanished, but all through the day she was irritable and morose, oppressed by the memory of the awful night. There was no further manifestation of the obsessive image; the obscene phantoms had descended again into the abyss. But the unfortunate vision seemed to have given new strength to the secret labour of Death, and diminished accordingly the feeble flame of Life. The dwindling of her energies became frightening. The casket without treasures was no longer merely empty; the carved wood was worm-ridden now, almost reduced to dust, devoured by some obscure army of termites; the lock hung loose; the lid was thrown back on its hinges.

Soon, this work was finished, lacking only the final blow which would crush and annihilate the wretched creature. The room took on the injured and almost funereal aspect of a sickroom; worthless flasks containing impotent tinctures were strewn over the furniture, and all conversations held within it were rendered horrid by their sepulchral tone.

The clock chimed the critical hour. It was in the evening. The doctor had gone, muttering uselessly to himself. After hovering over the bed for a while, asking vain questions of the poor mute whose voice had already been stifled by impending death, the priest had pronounced the dubious formulas of absolution and sat down to wait for any possible confidences which might emerge in the respite of the penultimate minute. A nun was standing alongside, her eyes fixed upon the moribund woman, on the lookout for some gesture which might signal the desire for one last

drink of water, watching that veiled expression in case its veil might suddenly tear to release a supreme smile.

The veil did tear. It did so when the dying woman sensed that her beloved was there, that the head which now leaned over her own agonising head was the adored head of her husband. The veil tore, and a gentle gleam of love illuminated the sad eyes which would soon turn their gaze towards the other side of life.

There followed, between these two beings, a macabre mute conversation – mute, because one could not speak and the other did not wish to speak, perhaps fearing to spew forth the turpitudes which swarmed in his heart. While the almost-deceased comforted herself with the illusion of a little more life, declaring with her expression and with the extremely feeble movement of her fingers the absolute truth of her invincible affection, the man whom she adored even in her agony could find no response save for a smile whose compassion scarcely served to moderate its indifference.

Having become weary at last of his dumbness, and of the pretence imposed upon him by circumstance, he opened his mouth to proffer abominable banalities and expressions of hope which were more wounding than injuries. He even talked about a journey into the country, assuring her of the benefits of travel, of the good results that might be obtained by a sojourn in the mountains of Algeria.

"We will think about all this later," he told her. Then, without any change of tone, he said: "Your sister is here. Would you like to see her?"

Without waiting for any sign of acquiescence, he left the room, and came back immediately, accompanied by a very beautiful girl in the full bloom of youth, whose passionately sensual attitude clearly denied her virginity.

The sisters had never loved one another, and the elder of the two – the one who now entered, radiant and insolent beneath her attitude of condolence – had never forgiven the younger, who was now laid prostrate, her precocious marriage.

By virtue of a sudden divinatory gift, the dying woman understood what had passed between her sister and her husband. They had the attitude of accomplices, both of them – and in the kind of glances they exchanged there was an indefinable intimacy which seemed invisibly to unite them.

The obsessive and obscene vision passed once more, in all its awful clarity, before her affrighted eyes. Paralysed by terror, she expired with the horror of having seen, standing before her, the Other.

THE DEATH ONE CANNOT MOURN

He was in mourning for one he was not allowed to mourn, unable to acknowledge his sorrow, for the one whose death had devastated him belonged in name and in memory to another. He, perhaps, suffered more than any other, and yet he was forced to smile, to listen to the anecdotes which were bandied back and forth – and even to tell them himself, sparing neither implications nor insinuations nor perfidies, because he wished to keep his secret.

He mourned, but he shed his tears within his throat and not upon his cheeks. Like one of Dante's damned, he drank from a poisonous and inexhaustible river of misery. Twice or thrice, intending to contrive a delicate and discreet grimace of surprise, he felt his face become contorted, and his gorge rise – and it required a superhuman effort, born of love, to prevent sobs from bursting forth to stain the solemn ceremony with scandal and ridicule.

The subdued company followed the coffined corpse along a desolate little path bordered with appropriately dismal firs. One by one they passed into the cemetery, and the conversation dwindled away, hushed like the noises of a forest at the approach of a storm, or the murmur of a flock at the door of the abattoir. Disquiet imposed silence by gradual degrees as the members of the crowd entered the house of the dead, each oppressed by the fearful awareness that one day he would enter such a place and not leave it.

In spite of his inner anguish, he sustained his pretence of indifference throughout. He pretended attentively to read the vain inscriptions imposed upon the insensibility of the marble slabs. The aspirations graven there revolted him by their frankness and their hypocrisy. The doctrine of the eternal survival of souls could not stir in him any

leavening of desire; he did not believe in it, and he did not want to.

When all the formalities were complete, the assembled throng, delivered from their solemnity, made their way back up the staircase. Once outside, he took care to present himself, as propriety and amity demanded, to the husband of the deceased, the marquis de V – . He clasped the old man's hand, and proffered some conventional banalities:

"I have been waiting for you, my friend," said Monsieur de V – . "You are the one who must give me your arm and escort me home. Come, I beg of you, save me from all these tiresome people."

Making a vague gesture of farewell, M. de V – withdrew with the companion in sorrow to whose care he had chosen to confide himself.

"Let us go," the old marquis continued. "Lend me your support, I beg of you. I am broken. I feel as if I were a hundred years old! All that remained to me of my strength and my life has been nailed up in a coffin. I suppose you think that it should have been she who buried me, she who should have closed my eyes and consoled my cold temples with a last kiss, like a dutiful daughter? Ah, my friend! You at least are with me – say that you will not abandon me! You are not so rotten. I know that you cannot do it, for I am the only one to whom you are permitted to speak of her, the only one in whose company you will be able to mourn her. There is nothing I do not know, you see; not only have I supported everything that has come to pass, but I have engineered it, and mark my words: my wife's adultery has been the salvation of my marriage!

"When I took her for my wife six years ago I was already no more than the shadow of a man. I knew that I was quite impotent to provide her with the expected pleasures of marriage, and thus I condemned her to a kind of hideous and humiliating widowhood – humiliating because, in her ignorance, she might believe herself scorned; hideous because, although I could not take full possession of the virgin who had been delivered unto me, I

was not incapable of lust, or of such amusements which an old man might derive from an innocent and docile creature. However, once I was wed, and at the threshold of the nuptial chamber, I became ashamed of the abjection of my desires. I went in to my wife, and took abundant sensual pleasure simply from momentarily caressing her soft and beautiful blonde hair, as a mother might have fondled her daughter. She was undoubtedly surprised – and more astonished still later on, when she came to understand the intimate secret with which I could not acquaint her. That acquaintance she received from you – and I could tell you the day on which it happened, perhaps even the hour, if you have by any chance forgotten them! You must remember the tenderness of the welcome I gave you on that particular day, and you must remember your embarrassment, your lies and your blushes? Children, children! Admit that you were afraid, and acknowledge that at the same time, you enjoyed the most delicious sensations!

"I was so little the dupe, my dear friend, that I would arrange your rendezvous myself, always taking good care to provide you with advance notice of my absences and my returns. Sometimes, in order to maintain the intensity of your love and desire, I thwarted your planned meetings by remaining for an entire week within the house, without stirring from my bed – requiring by my simulated illness the constant attendance of the unhappy Antoinette. Oh, I have been so very paternal, and you ought now to recognise the fact. Without my ruses, you might easily have tired of one another at the end of three months, and without my foresight, you would not have found that charming hunting-lodge on the far side of the estate, to which everyone believed that I retired on certain afternoons, and where I permitted you such tranquil intervals on so many beautiful summer nights!

"My duty as a husband was to afford my wife the most elementary pleasures of life; being incapable of doing so myself, I delegated the task to one who seemed to me worthy of the role. You have filled that role admirably.

She loved you until the very last, unknowingly whispering your name in the agony of her delirium.

"You both conducted yourselves honourably. Your discretion was perfect, and I am certain that the Marquise de V – died with an unsullied reputation as a heroic and faithful spouse. Yes, heroic – because she always presented a cheerful face to me, yielded to my will, and catered to the idiosyncrasies of an old man. And faithful – because only one man ever kissed her lips."

We arrived at Monsieur de V – 's home, and immediately went up to the marquise's room.

"I repeat," Monsieur de V – continued, "that I could do nothing more for her than an indulgent father. I have lost a daughter; it is you who mourns your wife.

"What the world might think of me, if this curious adventure became known, I can readily imagine. They would despise me. If that is what you are thinking yourself, I do not blame you. What does it matter to me? I have always regarded myself as a liberated man – liberated from prejudice and from duties of omission. There are men who have risen through the ranks of society by the strict observance of social convention; as for me, I have descended.

"That degree of conventional immorality which an honest fool would discover in my conduct I myself take leave to adjudge a high and absolute morality – and I am able, proudly and painfully, to embrace in the privacy of my dead wife's room the man who I myself appointed as her lover.

"Mourn, mourn, my friend! Rejoice in all the delicious afflictions of grief! Mourn the loss of one whom you are not allowed to mourn, anywhere but here.

"Take what you will of her jewels, her lacework, her shoes, her dresses. Among her dresses, there is but one lacking: her wedding-dress; the one which she wore the day she was given to you. That one is buried with her; she wears it in her tomb!"

THE MAGNOLIA

The two sisters, Arabella the beautiful and Bibiane the plain, came out of the house together. Arabella's beauty emphasised her youthfulness, while Bibiane seemed older by virtue of her plainness, so they seemed more like daughter and mother than orphan sisters.

They came out of the house which had been touched by grief and paused beneath the magnolia: the magical tree which had been planted by no one and which bloomed so magnificently even in the grounds of the desolate mansion.

The magnolia came to life twice in every year, after the fashion of its kind: first in the spring, when it pushed forth the green spears which would become its leaves; then again in early autumn, before the tired leaves began to wither. In autumn, as in spring, the proud display of the enchanted tree put forth huge flowers which were like those of the sacred lotus, each snow-white corolla cradling a tiny red spot as though it were a shroud marked with a single drop of life's blood.

While she leaned upon the maternal arm of Bibiane, who was always tolerant of her weaknesses, Arabella looked up at the magnolia's branches, dazedly.

"He is dying like the autumn flowers of the magnolia, which have withered on the branches. The one who should have nourished the flower that I am with the drops of his vital fluid is dying, and now I am destined to remain eternally pale!"

"There is still one flower left," said Bibiane.

It was a flower which had not yet opened fully: a bud which stood out among the complacent leaves by virtue of its virginal purity.

"The last one!" Arabella complained. "It will be my bridal ornament. But is it really the last? No – see, Bibiane, there is one more yet, faded and nearly withered. They are

like us – the two of us! Oh, it is a sign! It frightens me
... I am all a-tremble ... there we are, he and I, our
fates mirrored in these two flowers. I will pluck myself,
Bibiane – see, here I am! Shall I also have to die, like
him?"

Mutely, Bibiane lovingly embraced her trembling sister.
She was afraid herself, but she led Arabella from the sad
and sorry garden, away from the magnolia which had now
been stripped of the last relic of its former glory.

They went into the sad house, from which the prospect of
happiness had so unexpectedly fled, leaving grief to reign
in its stead.

"How is he?" asked Bibiane, while she lifted from
Arabella's shoulders the mantle which marked her as a
bride.

While Arabella sat down, as timidly as a child, to
contemplate the unopened flower which she clutched be-
tween her fingers, the mother of the dying man replied:
"There is no time to lose. He is dying, and his greatest
desire is still to be realised. Come with me, my daughter
Arabella – I must call you that although your husband-to-
be lies dying – and let the presence of your beauty bring
forth a final flourish of love amid the last round of prayers.
Death awaits you, my darling – would that it might be
otherwise! The kiss which his lips will place upon the
forehead of his bride is the kiss of one bound for the tomb
– but his last smile will defy the invincible shadows with its
radiance, a glimmer of light echoing in that darkness
which lies beyond the reach of your own beautiful eyes.
The son I bore is going to die; he is dying, and I am deeply
sorry that you must be given in marriage to a dead man.
To you, alas, who are so full of the joys of life, who was
born to lie in a bed of fragrant flowers, I can offer nothing
but the putrefaction of the tomb – oh, would that it might
be otherwise!"

They wept together while they waited for the arrival of
the men who were to witness the last rites which would

unite Death with Life. The priest came with them, not quite sure whether he had been brought here to tie the indestructible knot or merely to anoint the forehead, the breast, the feet and the hands of the moribund son.

They all went upstairs together, in silence, stepping as leadenly as a troop of pall-bearers. "He might as well be in his coffin as in his bed," whispered one of the men, "prepared for a burial instead of a wedding."

They hesitated at the top of the stairway, but the mother urged them on, repeating what she had said before: "There is no time to lose. He is dying, and his greatest desire is still to be realised."

In the bedroom, they all sank to their knees, save for Arabella, who took her place beside the nuptial bed, wearing her bridal gown like a shroud. When she too knelt down in her turn, touching her forehead to the edge of the pillow, the hearts of all those present went out to her, sharing her anguish. It almost seemed, as she lowered her pretty head to rest it on the pillow, that she was dying too. The bride-to-be laid her right hand upon the thin and wasted hand which lay on top of the coverlet, while her left hand pressed to her lips the unopened magnolia flower, emblem of her virginity.

The priest began to pronounce the solemn words of the marriage service. All eyes were fixed upon the bed where the son was propped up, supported by his mother. His face was tormented by knowledge of the impending catastrophe, his expression so despairing as to seem satanic; it was bitter with envy of those who possessed the life which was deserting him, angrily resentful of the love which must be left behind. The nearness of the young and beautiful Arabella served only to ignite a fervent but impotent flame of hatred in his hollow eyes. *How terrible his suffering must be!* thought the onlookers.

The dying man managed to raise himself up a little further. From purple lips which had already been touched by the cold hand of death he spoke, while the men made a

final effort to smile and the frightened women sobbed like mourners:

"Goodbye, Arabella – you belong to me! I must go, but you must follow me. I will be there – every night, I will wait for you beneath the magnolia, for you must never know any other love but mine. None but mine, Arabella! Ah, what proof you shall have of my love! What proof! What proof! Your soul must be reserved for me."

And with a smile which wrought a diabolical transfiguration of the shadows which lay upon his wasted face, he continued to repeat himself. His voice struggled against its imminent extinction, perhaps devoid of any sense but perhaps mysteriously infused with some unholy wisdom drawn from beyond the grave, saying: "Beneath the magnolia, Arabella, beneath the magnolia!"

For many days and many nights thereafter Arabella could not sleep. Her spirit was sorely troubled, and her heart was heavy. At night, when the wind rattled the dying leaves of the deflowered tree, and when the moon stood high in the sky, bathing its magical crown with bright rays cast down between the October clouds, Arabella frequently trembled with fear, and threw herself into her sister's arms, crying: "He is there!"

He was indeed there, beneath the magnolia: a shadow amid the fallen leaves which swirled in the wind.

One night, Arabella said to Bibiane: "We loved one another, so why should he seek to harm me? He is there. I must go to him!"

"When the dead call out to us," Bibiane replied, "the living must obey. Go, and do not be afraid. I will leave the door open, and I will come out to you if you call me. Go: he is there."

He was indeed there, among the fallen leaves which swirled in the wind. When Arabella came out to him beneath the magnolia, the shadow extended its arms to her – sinuous and serpentine arms which fell upon her shoulders, writhing and hissing like hellish vipers.

Bibiane heard a stifled scream. She ran out.

Arabella was stretched out on the ground. Bibiane picked her up and carried her back into the house.

There were two marks on Arabella's neck, like the imprints of two thin and bony fingers. Her once-beautiful eyes were glazed, transfixed by horror – and tightly clasped in the clenched fingers of her hand Bibiane found the second flower which they had seen on the day of her sister's wedding: the sad, withered flower which they had compassionately left upon the tree; the flower which was the Other; the flower which flourished beyond the grave.

THE ADULTEROUS CANDLE

She had a certain fantasy and a certain perversity.

This was what she wished: that on the very night when her husband returned from his excursion, her somewhat timid lover, tender and frail, would remain beside her until the morning hour when the train was due; and still remain, until they heard the noise of the carriage drawing up before the door; *and still remain*, until the key was tremulously turned in the lock!

For it is liable to tremble, the master's key, at the moment of opening the casket of its amours: he loves me, and already the thrill of impending pleasure has excited his heart, and the cage is closed upon the shivering bird. It expands with the warmth of seeing me; but as for me, my own thrill is of a different kind. I have no love at all for the man who has the right to take me by surprise, and to impose on me, at any hour decided and determined by him, his lordly pleasure. My meagre kisses signify nothing but the hatred I have for him!

And why do I love him not? What reasons have I? Alas, alas, there are none!

"There you are, my love! Give me your lips, my darling. You're very pale. Are you afraid?"

"Of what?"

"Of what we're going to do. Look at me! There's nothing untoward in my eyes."

"But there is! Little flames, almost. . . ."

"Almost?"

"Almost miserable."

"Oh yes, my darling, tonight I am miserable with all the affection which has built up in me for you. I melt like wax; I run like a burning candle set at the head of a bed where joy lies dying – but I must compose myself, for the funeral ceremony which we must undertake."

"Is it ended, madwoman?"

"It is ended. He is returning. I feel the vibration of the train,

the disengagement of the signals, the swarming crowds at the station, the opening of the carriage-doors. *That* door opens, too – the one there, by which you will leave!"

"When? Already? What time?"

"We have the time."

Ah yes! Shall I amuse myself? A dream: he thinks of me, he sees me. Yes, my dear, he sees me all alone, somnolent, ears pricked, eyes straining to see what time it is, avid for the exquisite and definitive moment – he sees me! Does he see me with your lips upon my mouth? Here is something I want you to know! Oh! Oh! Oh!

Her darling understood his lover's kiss far better than her earlier ramblings. He was wont to call her Lover, or even Madwoman, but she had never before seemed to him so impudently the Lover, or so completely the Madwoman. To believe it, or not to believe it, was equally hazardous; she was capable of bizarre imaginings, of hallucinations – and also capable of being true and certain. What had he understood, after all? The kiss. The return? Yes, to be sure, he needed to know about that . . .

"Seriously," he said, "what time will he be back?"

"At four."

"You are right, madwoman, we do have the time . . . but it is sad, sad, sad."

"Sad? Not at all," said the Lover/Mistress. She undressed her darling, and her little darling stripped his mistress; they gave themselves to pleasure now, teasing one another as if they were male and female cats; but it was the frail amoroso who seemed the timid she-creature, because his mistress was taller and stronger than he, an imperious queen of sensuality.

They enjoyed one another, and they loved one another; and while she leant her own head over the pale forehead of her happy lover, she lost herself in contemplation . . .

He is so pale and so still. There is not the least quiver in the muscles of his face! That half-open mouth, those half-closed eyes – it is as though he has fainted!

What of his heart, his little heart? Oh, they are so feeble, the beats of his little heart! So feeble, indeed that one can hardly hear them . . .

They cannot be heard at all.

"My darling!"

No reponse at all: no movement; no flutter of the eyelashes.

She takes him in her arms then, but he is a dead weight, and quite heavy. Unexpectedly heavy. So heavy, this frail lover, that even the powerful arms of the queen of sensuality are too weak to lift him up.

Spirits! Water . . . vinegar . . . smelling salts!

But he is dead.

Little darling is dead. He is dead, he is dead, he is dead . . .

He is dead!

She says it, she sings it, she weeps it: dead, dead, dead! And it is true.

She dresses herself, once she has come to her senses and is once again mistress of herself. She is no longer mad with love, nor with pain. She is serious, and decisive, and brave.

In the rumpled bed of their union, now carefully remade, she calmly laid out her lover in the most chaste attitude she could contrive, in the purest attitude possible, with the bedclothes tucked under his chin, his arms on the counterpane, his hands crossed upon his breast. She put a crucifix in his hand, because that is the most evident symbol of death, which clearly proclaims the final truth and the final state of man in a voice which is mute, but nevertheless eloquent, funereal, and absolute!

When she had placed the crucifix between the fingers of her darling, the courageous adulteress became fearful again, and so afflicted by her fear that a momentary weakness made her incline her head towards the pale head which sank into the pillow, and her lips towards his pale and cold lips; but she straightened up immediately.

This display must be taken to a grander extreme. A

97

more startling ostentation was required to provide a proper satisfaction and a worthy justification of her love.

She stripped the antechamber and the drawing-room of all their flowers. All the favours of spring were strewn upon the funeral bed: lilacs and roses, lilies and mimosas; all the scented tresses of a fairy garden!

When she had done that, she felt almost contented and slightly intoxicated.

Standing up straight, her fingers clenched and her breathing rapid, she surveyed the mad heap of flowers, and the pale head that was now nearly hidden beneath the roses. Suddenly, feeling that her discomfited brain was under assault from a chaotic army of sensations, she set out to arrange the flowers – artistically!

She did not wish to pause for reflection, nor to give a moment's thought to what had gone before and what might happen afterwards. She wished only to be brave; to exceed the bounds of womanly bravery and to be recklessly heroic. She wished to do her duty as a beautiful and benevolent adulteress, and then to lay herself down beneath the anger which would explode like a thunderclap in that insolent room, over the insolent peace of the vainglorious lover.

But how best to light the scene?

This final concern finally and decisively chased away the army of chaotic sensations.

She lit the candelabras which stood on the mantelpiece. Placed at the head of the bed, on a side-table, they looked like two burning bushes, their flames solemn and inextinguishable. But beneath that avalanche of light the dead man became hideous: the pale head displayed a whiteness more livid than the bedsheet, ghastly against the cambric of the pillow; pits of shadow were hollowed out under his eyes, and his nose was villainously elongated, and even the mouth seemed wicked – his mouth, which was so very gentle!

It was necessary to put it all in proper focus, carefully organising the play of the rays of light, maintaining an

appropriate pallor on the pale head, arranging the shadows so as to display his calmness and his beauty. One of the candelabras remained at the bed-head, the other was set up at the foot of the bed.

And last of all: the devotional candle.

She found it in a drawer, scarcely diminished. It had wept but a few tears. It was a paschal candle, a candle of glory which he himself had taken pleasure in acquiring. It was a candle both adulterous and blasphemous, for had it not illuminated, in weeping its first tears, the first kisses of the Mistress and her Idol?

That candle! Oh what durance there was for her in the sight of this torch of love, encrusted with grains of incense: a torch of consolation and of remembrance which they had intended only to light on anniversaries, which had been destined to be the measuring-device of their years of joy – and which now would bestow upon the dead man his last illumination, weeping for his death its paramount tears.

At that moment, the bitterness of her sin constricted her throat and troubled her heart.

The adulterous candle! In buying it, in profaning it, in igniting within the sacred wax a sacrilegious flame, in erecting it to bear witness to illicit amours, had she not bought death? Had she not secured the damnation of one whom she adored – and her own, for was she not condemned also? Did she not know exactly what would come to pass, *all* that which would come to pass, when the tremulous key had opened to her lord and master the door of the house of adultery?

But she did not wish to think of it – not now, not ever! Her bravery was in her acts and not in her thoughts.

She lit the adulterous candle and immediately knelt down, with her hands together and set a little apart from her body. And without the slightest commotion in her frightened breast she awaited the hour at which her master was due to return: a beautiful, benevolent, brave and glorious Adulteress.

THE DRESS

That very day, he encountered her: the new dress!

She came towards him, slow and proud, with the smiling and mysterious majesty appropriate to the aesthetic realisation of the long-awaited hour, with the teasing grace of an original.

It was definitely she; it was definitely the new dress.

For a week he had lain in wait for her at the corners of the streets: the wide, clear streets where she might deign to disport herself, displaying to watchful eyes all her unexpected glory, turning about, coming to a halt, setting off again, slipping by like a seagull soaring over the beach. Costumes "for the carriage" had no effect on him; all his affection was reserved for the "promenade dress", and for one occasion only: the first time he saw her.

The new dress, the spring dress, was for him the great annual event; he dreamed of it for months in advance, worrying about the weather forecasts, always hoping for an early warm spell, offering as a Parsee might his prayers to the sun.

In the universal renewal, the rejuvenation of the flesh and the leaf, the flower and the grass, there was nothing of interest to him but the dress, and the dress alone.

The individual details of the dress – the particular style and the particular material; what kind of bodice she had and what kind of skirt; whether she was modelled on the chalice or the cup; whether high-cut or low-cut; whether she was secured by hooks or buttons; whether her shoulders were padded and how she was gathered and where her hemline was – none of that occupied his imagination for an instant. It was sufficient for him that the dress was well made, well carried and *new*. That she could, by her artifice, hide grave corporeal faults on the part of her wearer was the last of his fears and the last of his cares.

Without a doubt, his love of the new dress was not

entirely platonic, nor was it simply the love of a few chiffons agreeably assembled upon some mannequin. He was not one of those fools who became enamoured of some item of lingerie, or of a corset, or of a pair of shoes, nor was he one to stand contemplatively before the window of some great emporium which displayed from top to toe the outfit of a new bride, half chaste and half ostentatious. No, not at all. But even though the woman interested him less than the dress, the wine less than its flagon, he did not separate the dress from the woman – or rather, to put it slightly differently, and to give a more precise account of the tastes of our strange friend, *he did not separate the woman from the dress*.

A naked woman seemed to him to be an absurdity, an anomaly – something like a bald parrot or a plucked chicken. Such a sight inspired in him a rather painful astonishment, and in certain hospitable houses into which the imprudence of youth had at one time led him, he avowed that he had had the sensation of being in a Daho-meyan cook-shop rather than a palace of pleasure.

Greek and modern Venuses seemed to him equally culp-able aberrations, and he could only admire and respect that statuary which conserved for him, if only in marble, the form and the lines of a woman's indispensible plumage.

That very day, he encountered: the new dress!

She was made of perfectly clear mauve silk, in the form of a cone truncated at the waist. Towards the hem, she was adorned with three hoops of black ribbon – the last of which, almost grazing the ground, seemed to be the minus-cule pedestal of a pretty and captious statuette. The precise neckline was also circled with black, and the shoulders and the arms were covered by a mantle of three collars of a darker mauve, from which emerged a pale and blonde flower: a delicate head.

She was a costume which would quickly become irritat-ing, for one would soon have seen too much of her, but her debut was utterly charming. Indeed, his eyes were quite content with the demise of the cloaks and furs,

satisfied by the spontaneous flourishing of the feminine shrub.

Having encountered the new dress, he instantly fell in love with her. His heart beat more rapidly; a sudden giddiness made his step lurch; his dream passed by, his joy paraded itself before him. Oh! if only that dress would consent to let him love her! Let her not be one of those insolent dresses which knocked things over, contemptuous of the purest and most sincere desires!

Oh dress, please don't be shy!

The dress was not shy. Like so many of her peers, she allowed herself to be followed, dawdling while she passed the display-windows. Then she turned discreetly at the corner of a street where no pedestrians walked, and disappeared through a door.

It was a room like many others, seductive to a degree, too heavily scented and rather spoiled by a divan which was too large and too obvious; but the dress was there, beneath his eyes, beneath his hands. He contemplated her, he kissed her, he breathed her in and became drunk.

On his knees before the dear dress, which stood up, rigid and disquieting, he pronounced mad and gentle words, and all kinds of stupidities, in a tone suggestive of prayer.

"As soon as I saw you, I loved you . . . Oh, such a mad desire! . . . I would have given I don't know what . . . You are so beautiful! . . ."

His pleasure, however, did not make him delirious to such a degree that he did not discern the quality of his conquest, and the kind of soul which animated the dress which was so exquisite. He withdrew from his ecstasy in order to investigate his purse, and without suffering the distraction of any odious bargaining, he met the demands which were as yet unspoken, and paid for the dress, the pretty new dress, probably as much as she was worth.

Then he recommenced his adorations, and the other let him proceed, accustomed as she was to all the most peculiar – and hence the most dangerous – fantasies. In time, though, she became a little impatient, finding these prelimi-

naries rather long and rather ridiculous. Ordinarily, she addressed her clients directly, and having divined their tastes, briskly satisfied them with skill and precision; but this one was bizarre. She tolerated him for a few minutes more, allowing herself to be admired – as she believed – and somewhat flattered by his delicate manners. At last she became impatient with delay, thinking of what awaited her in the open air: of the sun, of the streets, of all the amours to be plucked by means of the marvellous philosopher's stone which was her "new dress". She disengaged him, and demanded with a smile whether she was at least to be allowed to remove her mantle.

"No, no! The dress in its entirety! I want the dress in its entirety!"

And he dragged her towards the divan, already embracing her furiously.

Comprehension dawned, and she cried: "With my dress? Never!"

She made an effort to stand up, and she tried to unhook her collar, but she felt two hands squeeze it closed again, pitilessly. Head bent back, she fell inert upon the divan, and quite unconscious of his crime, ignoring the death of the flesh with which he intended to unite his own flesh, the lover of dresses slaked his lust.

THE FAUN

She had retired early after the evening meal, weary of the innocent laughter of the little children and the forced joviality which was required of all parents at this season of the year. She felt wretched, and more than a little unhappy.

What had annoyed and upset her most of all was the way that her husband took care to put on a hypocritical show of affection whenever the eyes of the world were upon them; like all other wives, she would have preferred it if he had treated her badly in public and behaved in a loving manner when they were alone.

After dismissing her maid she drew the bolt; then, secure in the knowledge that she would not be disturbed, she was able to feel a little less unhappy.

She undressed slowly and gracefully, imagining as she did so how pleasant it would be if there were someone into whose loving arms she might melt, someone who would murmur endearments as they embraced, complimenting the slope of her shoulder and the delicacy of her knee, thus renewing the assurance that she was desirable in body and soul. She amused herself with this melancholy pretence, quite content to languish for a while in the realm of the imagination, which surely held no surprises for such as she.

Though she continued to touch herself, innocence was eventually overtaken by shame, or at least by delicacy. She stopped and picked up her dress – although, like Arlette when Robert the Devil had favoured her with his intimacies, she would just as soon have torn the garment apart instead of hanging it up. But regrets were no use; there were bad times and there were good times, and that was the way of things. She gathered a fur-trimmed gown about herself, and knelt down demurely before the fireplace.

She took up the poker and stirred the fire, rearranging

and reinvigorating the incandescent logs. She soaked up the warmth, still restless with annoyance.

Why, she wondered, did she allow the hypocritical attentions of her husband to upset her so much? Could she not be more dignified? Was she not capable of sensible self-control, of keeping herself calm – on this of all nights. Why was it that she had to make herself unhappy, until she was so vexed, so overwrought and so sick at heart that she was on the brink of tears? If she could not contrive to console and control herself better than this she would soon be a nervous wreck.

The fact that it was Christmas Eve made everything seem worse; this was one of those magical days when it became a crime to be alone, when the company of others was so very necessary to stave off remorse and painful thoughts. She must try to be constructive, to make herself better – but she had not the strength of will to do it. Her thoughts wandered again, and became confused; and within that confusion there remained only one word on which she could focus her attention: Christmas! Sad, stupid Christmas!

The image came into her mind of a little girl, not long returned from midnight mass, who lay asleep in her bed, dreaming of the gifts which were brought to the infant Jesus . . .

But no, it was all too banal! All the world gave way annually to such sentimental visions, but to what purpose? They were the meagre consolation of undistinguished souls who had not the power to evoke more satisfying illusions. Such commonplace and vulgar thoughts were insipid and silly, unworthy of the investment of *her* desire!

Rebelling against her memories of youth and innocence, she turned her thoughts instead to the delights of sensuality. The warmth which flooded the hearth now that the logs burned more brightly was changed by the alchemy of her imagination into a wicked titillation. She amused herself with the notion that peculiar caresses were flowing over her, like little angels without wings, hotter and more agile

105

than the capering flames which played like demons about the burning logs.

She gave herself up to a dream of sumptuous fornication, imagining that she might sink into an unexpected stupor, a complaisant victim of desire, right there beside the fire with the fur about her – yes, with the complicity of that furry creature, of that amorous and devoted goat . . .

Some lascivious spirit which possessed that lukewarm chamber collected its atoms then, and began to materialise. A shadow shaped like the head of a faun fell upon the mirror which hung on the chimney-breast, and a curious draught stirred her hair, warming the nape of her neck.

She was afraid, but she was possessed by a perverse desire to inflame her fear; she did not, however, dare to lift her eyes to the looking-glass to see what might be reflected there. The feeling which flooded her being was achingly sweet; but that shadow of which she had caught the merest glimpse was alarming, strange and absurdly peculiar. She had had an impression of a solid and hairy head, of devouring eyes, of a mouth that was large and somewhat obscene, of a pointed beard . . .

She shivered.

He must be tall and broad, very handsome and very strong, this being who had emerged from her dream to make love to her! How she trembled within the compass of his arms! She continued to tremble, aware that she was possessed, aware that she had become the prey of some strange amorous monster which had lain in wait for her, had coveted her body.

The fur slid away from her shoulder, and immediately she felt a violent kiss scalding the bared flesh – a kiss so ardent and so powerful that she knew it would leave a visible mark like the brand of a red-hot iron. She tried to pull the mantle back to cover her shoulder – a belated gesture of modesty – but the Being would not let her do it; he seized her two arms with his own two hands. It did not displease her to be defeated so easily; the violence of the action was a tribute to her desirability. Her back and

her shoulders had been made to be seen, to receive such fiercely courteous kisses; did she not owe it to herself to enjoy the fruits of her voluptuousness?

The weight of the other's huge body pressed down upon her, and she felt the panting breath of the incubus upon her, like the heat from a forge; it made her want to laugh recklessly. "What a vile imposition!" she thought. "He is atrociously, beautifully masterful . . . I can see from the corner of my eye how he looks at me. . . ."

As she turned her head towards him, the bestial mask which was his face descended upon hers, and that mouth – so large, and certainly more than a little obscene! – crushed her lips.

She shut her eyes, but too late! For just an instant, she had seen the monster face to face, and knew that it was not the mere reflection of her self-indulgent dream – that in becoming real it had been deformed, into something so foul, so ugly, so intoxicated with a purely bestial lust that . . .

She was suddenly overcome with shame, and instantly straightened herself. And when she looked at last into the mirror which was mounted on the chimney-breast . . .

. . . She saw herself, naked in body and in soul, all alone in her empty, dismal room.

DANAETTE

While Danaette dressed herself after dinner, making her special and secret preparations, the snow began to fall.

Through the tiny holes in the lace curtains she watched it falling: the beautiful snow, falling, ever falling. It seemed so solemn and so sad, seemingly ignorant of the occult and ironic power which it had to fascinate the human eye. It seemed to be unaware of its own divine provenance, forgetful of those cold, bleak regions on high where its light crystals were born, disdainful of that human foolishness which analyses everything and comprehends nothing.

"There is a great battle going on in the sky," her old Breton maid said to her. "The angels are plucking out the plumes of their wings – and that is why it snows. As Madame knows very well."

The statement was peremptory. Madame did not dare to utter any contradiction. Every year, often several times during each winter, the old woman would impart that same confidence, always terminated by: "As Madame knows very well." It was irrefutable, and somehow rather menacing. The old servant had similar charming explanations for all kinds of events, always brief and neat, always stated as if they were manifestly obvious.

Madame, in consequence, ventured no reply at all; but as soon as her hair was done she dismissed the old woman.

She wanted to be alone – with the snow.

Her preparations were not yet half-complete, but she could no longer concentrate upon her toilette. She sat down on the divan near the fire, and watched with patient fascination the incessant and luminous flight of the downy feathers plucked from the wings of the angels.

What a bore it had become, dressing herself up like this! Adultery was always agreeable at first, in the early days when everything was still to be discovered – when one offered oneself up to the impatient and imperious kisses of

one's lover; when one was driven on by curiosity; when one could think of nothing but the delights of a new and more complete initiation. Then, it was like a beautiful baptism in the delights of sin. But when the intensity of that brief phase began to weaken, it could never be renewed, no matter how one sought to deceive oneself; there always followed a detestable decline into ennui.

How tedious it all was! There were so many things to think of, so many excuses, so many suggestions to be made and precautions to be taken; it was all so discouraging, and – at the end of the day – so humiliating.

"It is always the same," she mused, without taking her eyes from the falling snow. "In spite of the cold, I had better take shoes instead of boots. He made the suggestion himself! The first time, he buttoned me up again so carefully, almost devoutly, balancing my leg upon his knee; the second time, he pulled a button-hook out of his pocket and put it in my hand; the third time, he had not even thought of bringing one, and I was in sore distress.

"It is the same with the corset and the dress. He is impatient: he snatches at the hooks and gets the laces tangled up. I owe it to him, I suppose, to make up a special outfit which comes undone at a single stroke – in a twinkling of the eye I must stand naked, or very nearly. Yes, actually naked, for he wants me to wear chemises like cassocks, which open like curtains as soon as one has unsprung the tiny catches which hold them – this is the costume which supposedly suits my personality!

"But I must press on, regardless! I must put on my brassière and do up my corset, so that the old Breton will not say to me, in front of my husband, in such a scandalized fashion, when I come back by and by: 'Madame has gone out without her corset! As Madame knows very well!'

"Ah! how beautiful the snow is . . . !"

They are still falling, always falling, those soft and silky white feathers from the angels' wings.

She who had been a rebellious adulteress mere moments before became chaste and innocent again as that subtle and

monotonous snow, perpetually falling past her window, exerted its hypnotic effect upon her sensibilities. The peremptory foolishness of the old maid was recalled to her mind, prompting a strange pang of sympathy for all the angels who had lost their feathers.

That would be a singular sight, would it not? An angel with plucked wings, like one of those geese one sometimes glimpsed in the farmyards of Normandy, which had yielded up its vestments in order to make soft pillows and eiderdowns for the convenience of adulterers!

It was a ridiculous, childish image – and anyhow, the plucked angels would still be angels, and angels were unconquerably beautiful creatures.

The snow fell on and on; it was so dense now that the air itself seemed to have condensed into a polar ocean of white stars, or a flight of immaculate seagulls. Now and then, a breath of wind would send the startled flakes hurrying across the window-pane, making futile attempts to cling and settle before sliding down to pile up on the sill.

Forgetting the adulterous rendezvous which she had planned, Danaette became inordinately interested in these unexpected turbulences which dressed the window with clustered flakes. She found a peculiar pleasure in her observation of the way these cloudy constellations would form and crumble away again, slowly and majestically, with the absolute calm of obedience to their destiny. Her eyes began to close, tiredly, but she forced them to remain open, determined that she would not give in to her lassitude, resolved to stay as she was, watching the falling snow, for as long as it might condescend to fall.

She was defeated in this intention, though; her eyes closed again, drowsily, and she slowly drifted off until she was half asleep. But in the sight of her closed eyes, the snow continued to fall . . .

Now, the window no longer interrupted the flight of the guileless flakes. It was snowing inside the room: on the furniture, on the carpet, everywhere; it snowed on the

divan where she was lying, prostrate with fatigue. One of the fresh flakes fell upon her hand; another on her cheek; another on her uncovered throat: and these touches – especially the last – excited in her a sensation of receiving unprecedented and exquisite caresses.

Still the flakes fell: her pale green robe was illuminated by them now, as if it were a meadow spangled with fresh daisies; before long her hands and her neck were completely covered, and her hair and her breasts too. This supernal snow was not melted by the warmth of her body, nor by the heat of the hearth; it dwelt upon her body, dressing her form in sparkling attire.

Deliciously icy, the kisses of the snow cut through her vestments – going, in spite of her defensive armour, in search of her skin and all the folds and creases of her curled-up body. It was marvellously gentle, and it had a uniquely voluptuous quality which she had most certainly never known before!

In truth, the Spirit of the Snow ravished and possessed her – and Danaette allowed it to do so, curious to savour this new kind of adultery, delivering herself up to ineffable and almost frightful pleasure. She allowed herself to become the amorous prey of a Divine Caprice: a human lover unexpectedly elevated towards the unimaginable realm of the angels of perversity.

Ever and anon the snow fell, penetrating so profoundly into the depths of her enraptured being that she had no room in her for any other sensation than that of dying of cold, and being buried beneath the adorable kisses of the snow, and being embalmed by the snow – and, at the last, of being taken up and away by the snow, carried aloft by a wayward breath of turbulent wind, into some distant region of eternal snows, over infinite ranges of fabulous mountains . . . where all the dear little adulteresses, eternally beloved, were endlessly enraptured by the impatient and imperious caresses of the angels of perversity.

EVENING CONVERSATION

One of them was a young girl, the other a young wife, but those who came to the house to pay court to the young girl found the young wife attractive too.

Ida had married a gentleman who occupied his time in training horses for the racetrack; he delighted in donning a red costume, could sound a horn better than a huntsman, and relished the conversation of ostlers because he found it instructive. His wife was of little use to him, save for matters of decor and of perfume. Sometimes, he was attentive to her, at least with his eyes; he flattered her as if she were a filly and offered her a diamond or a string of pearls in the hollow of his hand, as though they were sugar-lumps for her to eat. Sometimes, too, he breathed in her scent with closed eyes, and having savoured it, compared it to freshly-cut grass – which he insisted on calling, in the English fashion, "new mown hay". With all this Ida was perfectly satisfied, for he denied her nothing, certainly none of the essential pleasures.

The essential plesures, for Ida, were: to rise at mid-day; to possess a wardrobe of beautiful dresses; to make music; and, when the evening lamps were lit, to deck her pure torso with more jewellery than Aline, the Queen of Golconda, had worn. She was aware that there exist beings named "lovers", whom wives are wont to regard with the relish which her husband reserved for horses, but she had never had the desire to attach one to her person. These huge beetles, in her opinion, were agreeable only in a troop, when they circulated discreetly in a packed drawing-room; and whenever it was suggested that such insects were capable of inspiring mad passions in wives, she laughed so loudly that her agitated diamonds reproduced the sound of a wave breaking on a stony shore.

The particular scarab who courted her sister Mora, however, was neither too bestial nor too ugly, even when seen

alone and close up. He was displeasing neither to Mora nor to Ida. Mora's most fervent wish was to marry him, and Ida was determined to be agreeable, not wishing to discourage the pleasure of the two children, assuming that in the natural course of things they would be glad to marry. His name was Donald and his slightly musical voice was as gentle as the whispering of the wind in a steep mountain gorge. His expansive gestures suggested recklessnes, but one could not believe that of him; reassured by the pale blue of his eyes and the gentle rosiness of his cheeks, women treated him almost as a sister, and if ever he boasted of his skill in handling the oar, they grieved to think of such adolescent grace being devoted to such rude exercise.

Sitting side by side at the piano, Ida and Mora were lightheaded with joy. Encircled by a multicoloured net of harmony which separated them from the rest of the world, they intoxicated themselves shamelessly. They were aroused but unsatisfied; they sought ecstasy, but only arrived at a delicious enervation, undoubtedly the result of the discord of their desires. Mora played for the pleasure of agreeable sounds, for the excess of vibration which music imported into her cerebral cells, for the intensity and the activity which rhythm imparts to the beating of the heart and the circulation of the blood. Ida, on the other hand, played to embroider an accompaniment for her dreams, and while the music designed itelf in vivid arabesques before her dazzled eyes she effectively lost consciousness of her being; lightened and simplified, she came out of herself, she was exalted – but only to descend again, all too soon, surprised and slightly suffocated. This illusion was even more powerful when, instead of playing herself, she listened to her sister play – for Mora had a considerable talent for rhythmic interpretation.

Donald came into the room. Although they had neither seen nor heard him, they divined that he was there. Altogether charming in the spontaneity of their resignation,

they immediately got up, leaving a passage incomplete, and came forward to welcome him.

Donald kissed Ida's hand, and Mora's forehead.

He always brought flowers: not conventional bouquets but real and entire flowers with their stems intact. It was his habit to bring only three, choosing them from among the most perfect and the most pure: immaculate white roses the colour of falling snow; or fragile and sumptuous magnolias, imprinted with a single drop of blood at the very heart of their beauty, which made them seem like sacred hearts or – as Mora would have it – proud white-clad Dominicans who have spattered their virginal breasts with love and crimson while drinking from the chalice of the Passion. He knew how to find simple violets of an azure as profound and as delicate as the eyes of fabulous beasts rapturously uplifted to the heavens; and cyclamens of such carnal and vivacious pinkness that they reminded one of smiling mouths raised to receive kisses.

On this particular day, he bore in his hand three divine daisies: three heavenly bodies born of a dream; three symbolic golden suns starred with lunar silver; flowers of resurrection. Mora and Ida each took one, placing them, as they always did, in their corsages. The third he deposited in a Venetian glass iridescent with hope, at the feet of the Unknown: at the feet of the one who was yet to be revealed; at the feet of the Woman whom the inevitable course of Love would create and shape from the shadows.

The conversation was intentionally trivial, in order to reveal with moderation and modesty, little by little, the blushing secrets of one soul to the amorous curiosity of another, attentive and disquieted. As time went by, Ida sought Donald's opinion as to whether emeralds were appropriate to her colouring, and whether one could mix them with pearls and diamonds, and whether their pastoral greenness was so stark as to be ill-matched with the whiteness of a bare shoulder. It was decided, in the end, that emeralds did not sit well upon skin which was unusually

fresh and blue-veined, but they were perfect when set against flesh of a slightly bronzed hue.

"I'm glad that you think so, Donald. In that case, I shall certainly be able to wear my emerald necklace, for I'm as brazen as an idol". So saying, Ida rolled up her sleeve, and displayed against her brown skin the delightful smaragds which were her latest present from her husband.

In due course, Mora asked his opinion as to the embellishments which might suit a violet dress. It was evidently necessary to decorate it, perhaps with sulphur yellow thread – and one must of course wear appropriate jewels, perhaps opals, or perhaps tinted pearls. Mora begged him to "Hold this here" while she tried the match, but when she displayed the colours by the piano the yellow seemed a little overbright and the violet a little too dark. "It must be the harp," she said, and searched for a different position, eventually contriving a strange improvisation in broken rhythm which would bring out by comparison and contrast both the delicate shades of the violet and – embroidered in arabesque – all the nuances of the yellow.

Then she played again, for a long time – perhaps an hour – without stopping, without taking the slightest notice of the falling night, seemingly heedless of the divine disturbance which spread, by means of her fingers, into the air.

Ida and Donald were seated on the divan. At first, lending only one ear to Mora's fantasia, they continued their conversation, but the exchange soon dwindled away. Mutely, they surrendered to the reverie, and they trembled like the air itself, possessed by capricious melody and swelling rhythm. Only a narrow gap separated them; a slight shift filled it. Donald, excited, leaned to his right; Ida, oppressed, leaned to her left. First their shoulders, then their knees, touched; then their hands found one another and twin currents of carnal electricity moved though them, weakening them and, at the same time, activating subliminal sensations.

The flowers, the emeralds, the shoulders, the arms na-

kedly displayed, the sulphur and violet corsage dreamily imprisoning Mora's beautiful head: all of this, together with the persuasion of the music and the falling night, steered the course of their dreams towards the realm of sensuality. So utterly were they captivated that, without really knowing it, believing that they existed only in the world of fancy, ignorant of their tangible reality, plunged into the uncertainty of a dream, unsuspecting of the actuality of their act, they kissed one another gently upon the mouth.

The prelude was imperative: Ida collapsed, eyes closed, as though she were couched upon a bed of clouds; and she received Donald into her arms, with an entirely nuptial grace.

When they returned to themelves, they were unblushing; they did not know what they had done, and they never found out: the only memory which they retained was of a few exquisite minutes devoted to a voyage in the sky, of a pleasure which was at one and the same time sharp and gentle, infinitely pure and utterly supernatural.

However, when Ida instinctively readjusted her costume, she perceived that the flower secured in her bosom, with its golden head starred with silver, was completely crushed. She promptly got up, and went to fetch the one which had been deposited at the feet of the Unknown, and she set that one at her own: on the breast of the woman who was yet to be revealed; of the Woman whom the inevitable course of Love would create and shape from the shadows.

At that precise moment Mora, who was still playing, felt a terrible thrill cut through the very marrow of her bones.

STRATAGEMS

Bitter dalliances with a succession of women.

The earliest memory, distant now. She came to me: the gaucheries of a little grown-up in a school smock. On the smock, spots of ink; on the nose, freckles. Eyes the colour of mulberries; teeth like hazelnuts: mulberries eaten together; hazelnuts crunched in the hollow paths along the hedgerows; and in the grass, the dewdrops and the fresh flowers.

Afterwards . . . Oh! that one was truly the real thing. In being near to her, speaking to her, laughing, blushing, there was a joy altogether new, the joy of the first flowering. Her hair curled down so prettily over her forehead.

Chloe sang, a washerwoman at the stream. Oh, daughter of kings! Oh, ancient Homer! I believed that she was Nausicaa.

> He set his hand upon my stomach.
> I told him: set it lower,
> I told him: set it lower!

Chloe sang, a washerwoman at the stream.
Afterwards ?
That is all I now remember.

The next? The lowered blinds: passing the telegraph-poles, the trees, the little houses. On the turn-tables, the wheels rumble. The dusk is violet. The rolling rolls on, the fleeting interlacement . . . by the carriage-door, adieu! Never again? Never again. Your name? Your dwelling-place? The lips are taken up with kissing, they have no time to spare for speech. Oh, this train that goes on and on! Oh, my life that goes on and on!

117

After that? Encounters. No, no more. Yes! Why not relive such things for a while: the agreeable dreamer on my shoulder mourns her exile. She is afraid, at night, to sleep alone . . .

A little shopgirl, very comely in the economical get-up of her class: "No presents," she said, in a firm and discreet voice. "I'd rather have a new line in my passbook. My husband is perfectly content with that; he calls me his ant. When the thousand is up, it will make up the rent of a decent place, my pussycat." She was truly charming, in her silences.

A silent footstep on the bare parquet. The door is pushed, unbolted at the appointed hour. The light is imprudent, but pleasure taken in the dark becomes too languid. But there are eyes of a sort at the tips of the fingers: cat's eyes made for the shadows . . . sometimes I blow out the light. I love your heart more than the embroidered wreath you wear upon it – and you do not like distractions. The leaves are falling. To Paris? There, she expected the unexpected.

I remember that she did not like distractions.

Truly, was it worth the penalty? The penalty which she paid?

> Adieu, my maidenhead.
> Ha! You are leaving me!

Said the little maiden . . . Truly, was it worth the penalty?

The Swedish one loved me; and we had such lovely chilly rides towards the pale blue of the polar nights. Ah! how she wept, that day, and what unhappiness I visited upon one who was so beautiful!

That is how it always ends – but I have found nothing since like the chilly blue of those polar rides

To set the spirit in the savour, the soul in the perfume, the sentiment in the touch . . .

Desires, grenades filled with captive rubies which a nip of the teeth trickles dazzlingly forth: the nip of a woman's teeth.

Well brought up women know how to bite. They should not be mistaken, these guardians of Milesian tradition, but they are very much the same; true artists are rare.

Are these bitter dalliances with a sucession of women *necessary*?

At the Louvre, standing before the *Mater Dolorosa* whose eyes are two drops of blood (*o quam tristis et afflicta!*): a woman enraptured (I believed so at the time – but she was simply very bored) who had interested me suddenly, when she had turned her head towards the indiscreet image, by virtue of the enervated coldness of her expression, the vague irony of her frosty smile. The blondeness of her hair assumed a clear rust-red shade beneath her black bonnet, which was secured in front of the pearly amethyst ears (quite equitably matched by the faded violet of her pupils) by strings pinned by an ancient silver brooch.

I offered some trivial politeness, which she repeated . . .

When she walked on, having invited me with a slight – almost gentle – blink of the eye to accompany her, the undulating slowness of her movements displayed a body developed according to the oriental aesthetic, with thin bones, a supple frame and compact flesh, not without a certain slight tendency to disproportion.

We went out by the Mantegna. We discussed it briefly, as confused in ourselves as we were perplexed by its symbolism. She confessed herself intrigued by such enigmas, and in a voice which matched the indolent allure of her procession, unveiled a little of her inner self. I perceived then that something unacknowledged and imprecise – a secret tendency of which she was unconscious and could not name – was saying to her: "Here is that which you want."

While descending the staircase towards Ariadne, she

stopped in the middle and went back up a few steps, as if she were bidding farewell to the statue of Victory. But I understood that this was something of a ruse, for she turned again very abruptly: she wanted to study me without appearing to look at me.

"To tomorrow!" say I, with an appropriate fervour.

She deigns to laugh a little, lowering her veil in a pantomime which is perhaps not too problematic — and then she goes on.

I catch up with her again on the staircase. We leave the purple robe to shiver in the glorious winds of the Archipelago and, mutely in accord, we go through the door — friends already, it seems.

I hear the inevitable catalogue of complaints: no man has attracted her desire more than another . . . she had a husband who made the usual claims upon her, who initiated her in the customary intimacies . . . he is dead now . . . the kind of person dedicated to climbing the rungs of the social ladder proudly and methodically . . .

I am not listening. What does it matter to me whether she is a mere girl or a marquise, or both? I am thinking: here is a companion for the game of elementary sensations, flesh malleable to intimate experiences, and a soul sufficiently becalmed by ennui to accept navigation towards that isle where fabulous creatures rejoice in fabulous creativity . . .

". . . rich . . ."

At this point in the conversation, I interrupt to say:

"The simple perfume of a shoot of mignonette can have a powerful effect, and all the actualities of opulence are surpassed by the simple crumpling of a piece of ancient silk. . . ."

Having crossed the Seine we reached the desert spaces of the Avenue de Breteuil, where Solitude herself has taken her refuge, by which she has been won over. She interrogates with a desperation which flatters me, in my chosen role of extravagant consoler:

"To what extent can an unusually perspicacious soul penetrate the darkness of another?"

"Hardly at all."

"What, then, is the use of intimacy?"

"It is the trading of wilful desires."

That is my reply – and why not?

She dismisses me. We move apart, always unknown. It was imprudent, but by the time I realise that, it is too late. "What is it to me?" I repeat yet again, the baptism of her essence, "and what else do you require of me, provided always that I make you suffer most agreeably, except to become insensate?"

She came home with me.

"A scapular monk chants antiphonies to the Virgin, who wept for terror and for love . . ."

"Where?"

"There, on that parchment ruled in red and inscribed in black, don't you see? – and the other one, who softened the candle-wax of the Abbey seals in the flame of an iron lamp as twisted as a wayfaring tree, don't you see him? – and another who sprinkles the sacred flames of the garden of dreams, don't you see him? . . ."

"It's you!"

"She is beginning to understand."

"Daphne! See how the miserable Laurel Wreath lures Apollo haloed in gold. She invests herself with bark, ironically, and the crimson buttons at her unkissed breasts flourish between the golden horns of jealous Diana. No goat has browsed the mossy strands of its bare branches, and the drunken Faun has forsaken the unpolluted hiatus of its sexual cavity, jewelled with amber and topazes, for the crevices of perverse ash-trees . . . Apollo would have delighted in you, you see? See how beautiful it is, more amorous than a turgescent thyrsus, or an arched catkin weeping pollen tears . . ."

"Yes, but this halo?"

"Oh! I love you! I will love you till the green Dragon loses his horns!"

"Who said that, dear, you or I?"

"Oh! when I speak, it is only to say the things which everyone says."

Like the A'lmindor that powdered Eisen, I spread myself out over the cushioning grass, and I compliment her on the extreme whiteness of her colouring. A rap of her fan on my knuckles is my only reward.

"Are we not embarked for Cythera?"

"There is no breeze to inflate the sails of mauve silk, and we have not a single oarsman."

"I assure you that I will do the rowing, charming Acine, while you man the helm."

"Oh, but I am so shy! One distraction . . ."

"Don't worry about my part!"

"Oh, I wouldn't take that chance!"

At her home.

While still disturbed by the enchantments of the Sonata which my wandering finger has designed, I sit down some distance away from her, on the sofa, with my eyes closed.

"Ah! Is this, then, how you trample down my true desires? Behold the first stroke, the first cry, the first smile, the first weep, the first doubt . . . she flies away! Come back! Come back – the crimson of your dress bloodies my eyes; I see the red nullity into which my life will darken; all is red: your mouth and my devoured flesh! Your breast flourishes with red made dulcet and dolorous . . . what delights there were in the harsh dream where the heart was flayed! Her mouth gives me fragrance and her hair caresses me!"

"Where are you, then?"

I am half-way there: her mouth gives me fragrance and her hair caresses me.

"Read me and I will bring forth from the harpsichord such mortifying harmonies . . .

"An evening in the heather. . . ."

"Where are you reading from?"
"I'm not reading – I speak from the heart."
"In what key?"
"The minor – oh, the minor!"

> "An evening in the heather so forlorn,
> With a smiling and exhausted lover;
> While beetles climbed the horsetails,
> And blue jays shook the frail branches,
> The enamoured cries of tree-frogs
> Could be heard among the meadow-sweets.
>
> A dog, at the threshold of a half-open door,
> Howls mournfully at the new moon on high,
> Which brings slight joy to the blindfold sky;
> The milch-cow stirs and lows in the byre,
> A dog howls mournfully at the new moon,
> On high, at the threshold of a half-open door.
>
> Our feet bruise the diamond-dewed grass,
> We scale the silvered ravine,
> Its slope as steep as effaced sensation,
> Knees weary and hearts refreshed
> By scaling the silvered ravine
> And trampling the diamond-dewed grass.
>
> While we climb, unsettled at heart,
> Yet smiling, towards the curving ridge,
> The dream, becalmed half way,
> Sits down to think with head in hand,
> And we climb towards the curving ridge
> Still smiling, and unsettled at heart."

I have gone forth, bravely, half-convinced.

Can one spend hours in the company of a woman, in an intimacy which goes as far as physical contact, without attempting the decisive penetration? I can no longer find, when I try again to see it, the vague irony of her smile; it is her eyes, instead, which now express disquietLet us see whether the tacit accord which binds us will not exclude the final pleasure . . .

. . . As was understood, you have come to fetch me, and the railway carries us away across woodlands reddened and gilded by the spent passions of summer. Autumn is as joyous and gentle as a premature demise: the beeches smile at impending death; shorn like bacchantes, the elms fall asleep; the oaks, like gladiators with tensed muscles, ironically await the final aura; only the pines and the larches are saddened by their immortality.

The train stops in the untracked heart of the forest. There are no houses, nor any visible road; we venture forth on a haphazard trail through the undergrowth.

Around us, the air is impregnated with mingled odours: enervated honeysuckle and acrid elder in imperfect accord; murmurous mosses and decaying leaves are other fading notes in the unsettled chant.

A few steps brought us under the greyness of alders, where the moist vapours of fresh mint peppered our intoxication.

Daphne (she almost believes by now that her name is Daphne) sits down and stretches herself out. Lying down next to her, it is her scent that I breathe. Unexpected perfumes: her orange hair which at times – perhaps by illusory means – flourishes with the scent of oranges, at this particlar moment exhales the complex odour of figs dried by the sun; the back of her head reminds me of the leaves of the ash-tree; and on the neck, towards the throat, there is a scattering of little foxgloves . . . "O charming bush laid low by the wind of desire, I desire nothing but to submit myself to the extremities of your branches, to these hands which are moistened by the dewy grass, to these wrists imprinted with the odour of daisies, to your head, to that

mouth, fountainhead of the forceful humidity of flowering mint. . . ."

Flexing her knees, she raises herself up, and: "Let's go, shall we?"

The voice is abrupt, irritation tending towards anger: the amusing anger of a bird which hoped to drink a droplet from the crevice of a leaf, but overturned his glass while settling upon it.

We walk on, side by side. We are silent, attentive only to the complicated emanations of the forest which evaporate so abundantly this evening – woman, weary of the reserve of the day, liberates imprisoned follies as dusk begins to fall.

The train must have been waiting for us, for scarcely are we seated in our corner than the whistle sounds. It waited for us and it brings us back, exactly as we were on our departure.

"It was hardly worth the trouble," say Daphne's eyes!

At the door, before opening the carriage, I take her hand and kiss it – her hand, still damp with the freshness of the dewy grass.

At her home.

I discover her among flowerbeds of old silk ribbons, her manner very amused and yet serious, all sensation concentrated in the fingers which torment themselves with shimmering caresses. The thumb on the weft rubs against and perceives the floral design, all the elements of the pattern raised in relief.

She closes her eyes:

"Roses . . . roses enlivened by some carmine, wild roses rather, and at the heart of each – that's right, isn't it? – there is the yellowy white of the protruding pistil. Foliage in two shades of green grows around them, opening out wider; roses and leaves alternate along the material like the beads of an oriental rosary, slowly unrolled on a base of very pale green, as pale as a reflection of overhanging leaves in water."

She threw away the material without looking at it.

"Yes, some days I see better with my fingers. The perceptions are finer, penetrating the flesh like very gentle stings ... How absurd that must sound, very gentle stings!"

I only smile a little, for I am here in my turn, kneeling among the silks, and a contagious sensitivity overtakes me: it is relaxing, even more so than the grass ...

Oh, Galatea (she almost believes by now that her name is Galatea), here is a burnt crimson which lets loose a carnal warmth, as carnal as your feverish cheeks! The cerise velvet draws my lips as your lips do ...

"You embrace my ribbons now!"

She laughs, a little upset. She is sitting on her heels; I lean forward; she comes to her feet. To steady myself, I reach out my hand at random: it finds the bare heel of Galatea, coming out of its sandal, and the fingers amuse themselves so very gently, caressing the blushing skin towards the ankle, quivering a little upon the joints ...

The heel has escaped me: she has seated herself on a cushion, and the unfamiliar red dress, with ribbons red as poppies, has been brought back to cover the sandals.

We start to knead the amusing silks again. Mysterious blues come into view, overpowering the reds and denying the greens. Adieu, grass! Adieu, virescent shadows extending on water the reflections of overhanging leaves! Adieu, crimsons burnt by desire! Adieu, carnal crimsons! ... Open windows are blue, and we depart from here towards the bright heavens ... I regain my feet now: on contact with this blue-green velvet I have jumped into the cockpit, and I find myself again. Galatea, I kiss the blue-green of the veins which ramify upon your wrists ... Green? What green? No, it is decidedly blue, this wrist, by virtue of the veins which encircle it with their blue tracery ... O blood, carry me towards the heart of Galatea! O fabulous labyrinth of the veins, carry me! Take me there, fabulous labyrinth of the arteries, take me and conduct me by the secret ways through the intimacy of her flesh ... I will follow the contours at this very moment ... But the dream gives way

to the hands: Galatea abandons herself to my precise hands: here are the arms formed in their perfect posture, with the complex junction of the elbow: the crook where the tensed muscles are opposed, and where the double point of the bone is exposed beneath; and towards the shoulder, the adorable and fugitive curve of the muscles of the embrace ... The shoulders, the neck, the nape where the little vertebrae stand out, the lobed ears like sea-shells, mysterious conches in whose depths there sounds a susurrus of love ... The back shudders like a billowing wave, and lo! the wave divides into two breakers: a marine ridge dedicated to Aphrodite! ... Hips ... The complexity of the female sexual parts! ... Waist, I design you with my joined hands, and with such delicate finger-play I model you, breasts of Galatea, and you, abdomen of Galatea, a pillow softer than that pillow of clouds where Phoebe rests her lunar forehead ...

The artful night has stolen upon us: Adieu, Galatea.

At my home.

Set low down, as though for children, emerging from an accumulation of cushions, the little citron table bears a bronze dragon, where green tea is already simmering; opaline eggshells ready to be filled; Rhenish wine and a bohemian flute; special pastries with spices; a few preserves, tamarinds, cranberries and Chinese ginger.

When she comes in, this capricious preparation unsettles her. It is as if she suspects the hidden presence of some philtre, that aphrodisiacs have undoubtedly been secreted here, cunningly measured out and dissolved in the pâtés, the fruits and the fluids ... It is as if she intends to divine my true intentions, and is singularly determined no longer to desire that which she believes that I desire!

But I am not embarrassed by such a disposition. With a smile, and a series of amusing gallantries, I divest her of her veil, her hat, her mantle and her gloves.

Suddenly, she recovers her muff, which she threw aside on arriving, from an armchair, and she hurls it in the air,

right up to the ceiling. She catches it, throws it up again, and misses it. I fetch it, we play with it as though with rackets, she is flustered, runs to the mirror, pats her curls, sits down: it's all over.

Her defensiveness has evaporated during the game. She tells me about her day. I am patient enough while the minutes go by; they are easy to bear when one has faith in the promise given, although there is always a tiny thrill of uncertainty. Eventually, the familiar step climbs the stairway of the spine – the kiss by which one takes possession . . .

"A rather feeble prize," Galatea remarks. "If only one could let oneself be taken . . . taken, in the end . . . without dispossessing oneself."

"A caged bird reserves to herself, by the good will of her gaoler, her material liberty. The joy of the fowler would surely be greater if he knew that he had captured a soul – but that can never be known, can it? How can one penetrate the mysteries of metempsychosis, to assure oneself that the quarry is animated by some divine breath?"

"How does the presence of a soul become manifest?"

"I don't know. A creature which has one acquires an innate spirituality; a human with a soul is like a branch of box-wood thrown into a petrifying spring, covered by an impermeable layer which prevents the oozing out of thoughts."

"Have I one?" Galatea demands.

"Dear soul of my perversity, would I love you if I had not sensed a soul in you?"

"Perversity? Oh!"

Evidently, she believes that perversity consists of laying down a woman on combinations of cushions or on the carpet, and there violating the mysteries of her lingerie and her hosiery, to obtain relief therefrom in spite of her – and not without impertinence.

"Am I then," she muses, "no more than a soul, endowed with a certain corporeality formulated according to an adequate aesthetic standard: your completed Galatea?"

I pretend not to understand, and pour out the tea. Galatea prefers intoxicating Rhenish wine to over-aromatic tea, and she is soon very excited, offering me cranberry jam to eat from her spoon, and cake to munch broken off by her teeth, and wine to drink from her moistened lips . . .

As for me, I kiss her fingers, which taste of ginger, and I feel myself hungering for living flesh more odorous in the skin than yellow tea – for your highly-spiced hair, Galatea, for the fine emanations of your flora, flower, and the hot peppers of your fauna, woman . . .

No, no more, only to drink you and to eat you . . .

. . . Ah, what flavours I have found, original and stimulating! . . .

No! Remain thus, Daphne, rendered eternal by desire: enter into your bark and dream until that time when, haloed with gold, I come to apply my saddened lips to the arborescent flesh of my sterilised amours . . .

Here ends the game of elementary sensations.

THE PHANTOM

THE PORTAL

In the mornings of our love the sky was white and forgiving: sidereal breasts extended towards our lips the authentic milk of primal refreshment, and favoured the polar pupils of our eyes with a light to equal the transparency of our desires.

We were awakened by bells which sounded ecstatically in our heads, calling us to come out of ourselves. They chimed in our heads and above the town, like those which called the faithful to prayer, but we could not mistake them for the common bells of twilight. Morning claimed our obedient and joyous souls, and would not surrender them. Our bodies, chilled by anxious expectation of the cloak of eternal sleep, were warmed and consoled in their very depths by the hope of union; and the solitude of the flesh was eased by the grace of the white and forgiving sky.

Your innocence sets you apart from your sisters, and brings you to me. I do not know you, sisterkin, and your spirit frightens me. Why do you come to me naked? The body is the modesty of the soul: go dress yourself, for you confound my chastity and excite in my spirit the pure concupiscence of love.

I wish to bathe the nudity of my desire in the fresh waters of your thought, sisterkin. Only admit me to the depths of your inner being and you will know the secrets of my nature. Only let me in and I will fall like a sharp stone upon your unblemished breast, and gently pass to the very core of your being, and release such a fount of blood that the sky will be splashed by love.

But why do you want to stain the immateriality of my peace with the spilt blood of love, O mad and cruel

sisterkin? I have neither breast nor blood, and you have neither cutting edge nor gravity. We are more intangible than the track of a bird in flight, more invisible than the perfume of roses. I dearly wish to love you, mad sister, but go clothe yourself, that I may see you!

But you too are naked, poor soul: as naked in essence as I am myself; and *all* is metaphor, in the end. If I clothe my body again, what will you do with it, and with what eyes will you gaze into mine?

Essence is essential and form is formal, but form is the formality of essence.

We will place seven roses at the seven keys of the viol, and the rainbow shall provide the strings.

Inhale my odour, O Heart; I am fragrant and dying, by virtue of the death of the roses.

Inhale my breath, O Queen; I am amorous and afraid, I am afraid of your happiness, O flower!

Hear my sighs, O Lord; my sighs have broken the viol with the seven strings, but I shall make seven more with my seven desires.

Hear my speech, O Folly; your words have broken the strings of my heart, but I shall make seven more with your seven sighs.

Look into my joy, O King; the flowers are dead, the viol is dead; all are dead save for you.

Look into my Heaven, O Beauty; the seven colours have died of joy; all are dead save for you.

THE PALACE OF SYMBOLS

Form is the formality of essence. We accepted that aphorism, which the voice of Heaven ringing in our heads had not denied. We seemed real enough to ourselves. We were real, at any rate, in terms of the most common – though not the only – objectivity.

Our pact was made in a gambling-room, amid the assaults of a host of indiscreet costumes, from which we were separated by the pallor of our ennui. It seemed that we were surrounded by the excited wailing of infants; their voices were alike whether they had blond hair or white, whether they were winning or not. Some of those embarked upon this mass assassination of consciousness wore a bloody stain at the right side of the heart, but others who carried no such sign had been no less courageous. The sight distressed us both.

"At least they have the satisfaction of having done their duty," I remarked, "and the pleasure of secretly repeating to themselves that the cultured pearl is always a pearl, even in the obscurity of its closed shell. The pleasure of being a scoundrel can be adequately savoured in silence . . ."

"No," she replied, "it's not the same. Vile souls like nothing better than the ostentation of their vileness. It brings them that esteem to which they are so fully entitled; silence and obscurity render them inconsolable."

Having thus struck up a conversation, I asked her to tell me her name.

"I am a stone and a flower; I am hard and perfumed; I am transparent and sensual; I am coarse and I am gentle; I am two and I am one. Am I named for the stone or for the flower, in being named Hyacinthe?"

"O gem of perfume, O flower adamantine; I hear only the music of paradise in the fresh syllables: such a delicate sensuality; such fraternal eyes, where a kiss might linger in the hope of drinking a marvellous ether!"

We watched the games which our peers played, so

dissimilar to the play of our own dreams. We explored the astonishment of our antipathy, without taking pride in the sad vanity of our exile.

"Do you find pleasure in living?" I asked.

"Oh, so very little!" she replied. "So little that I cannot tell whether I really live at all. I am discouraged by the monotonous uniformity of my days, like a musical scale devoid of melody. I have long dreamed that some redemption might fall upon me from on high, from the very highest, and I would be direly grateful for any divine pain which might hazard to pierce my heart and awaken my soul. But I remain untouched; I am not numbered among the chosen."

"The choice of martyrdom is made by the martyr – but why should one desire it? Take pleasure in your dreams, and in your flesh. If someone were to speak your name with love, would you not be joyful?"

"Yes, to have given joy. But with what object? Were I to love, I would crave such extraordinary extremes of sensuality that eternity itself would be jealous of my ephemeral flourishing."

"Eternity is not jealous; it is protective. The shelter of its permanence is open to every significant act: it is the palace of symbols. Inaccessible to the egoistic vanities of everyday gesture, pitiless of negative prejudices, it has a charitable welcome for all those spirits which play host to the Spirit of Love. But all around that palace, there are pools of absolute sterility: those who deny life fall into them; and even the formicary of putrefaction is denied to them; they become the nothing that they wished to be, and sleep eternally in the sterile pools."

"A palace without perfume and without flowers! Where are the flowers?"

"They are painted on the walls."

"But they are dead!"

"No, they are living – like thoughts."

Hyacinthe became still while these ideas agitated her soul. She stood against the background of a great tapestry

where pale shadows moved. Again she said: "They are dead! They are painted on the wall! Sometimes, I seem to myself to be painted on a wall, dead – no more alive than a faded thought, or those apparitions which pass me by, like those which are all around us now! They are always around us, are they not? Am I any different from the pale shadows on that dead tapestry? You dare not declare that I am alive, do you? You dare not, for fear of being deceived."

"The privilege of living! But you will be the only one, Hyacinthe, the only one among your peers! You will only live for the one who will make you suffer – and that may not always suffice. O madwoman, more primitive than the abolished goddesses of old, what ambrosia of divinity do you believe that you might drink through the innocence of your blue eyes? Even Christ could only have life at the expense of suffering and death: he came to demand with a barbarous candour the crucifixion of his chosen flesh; beneath the whips, the crowning thorns and the nails his holy blood gushed forth upon the pitiful rocks like fresh water upon a desert."

"I desire to strengthen that shadow which I am," said Hyacinthe, "I desire to verify myself, and to exalt myself. What does it matter whether the means to that end are the velvet wings of the Chimera or the rugged back of the Dragon? But . . . what exactly is it that I desire?"

"To abandon yourself."

"Yes! And yet I love myself, if nothing else!"

"It is your destiny."

"But do no injury to my will."

DUPLICITY

We ventured towards the arborescence of the twisted pillars in the crypt of that gentle and discreet church where we heard the childish, welcoming voices singing psalms to the interiors of our hearts! There were shadows and flowers there; candles and incense; and there was a great silence: the inevitable silence of adoration and fear which falls when the Victim lifts herself up for consecration, beneath the folds of the Holy Shroud.

"Damase," Hyacinthe said to me, "kneel down and be repentant of my faults, for I am sworn to belong to you. Take charge of my destiny, and accomplish it in accordance with the laws of the redemption."

"Hyacinthe, I take upon my shoulders that burden which you lay down at the feet of Mercy."

"I have abandoned myself, as you have demanded."

"Entirely?"

"Am I twofold?"

"There is the flesh and the spirit."

"I am neither flesh nor spirit: I am woman and phantom. I have become – that which you will make of me."

"You have become that which you are; you will flourish according to the power of your own will. What can I do, save to pluck you, and make you sensitive to the value of the sap which flows from your wounds? To live is to deny all joy which is merely personal, and all selfish sorrow. The debauchery and pleasure of mere existence is the third sin, but it embodies the two others. Yes, entirely. You owe it to yourself to refuse neither that infinity which you have chosen by creating yourself, nor that finitude which you have selected from the multitude of sterile grains by loving yourself. Rejoice in the fecundity of adorations and smiles, and in the torture of being crushed in the wine-press in order that you might be drunk: the purest of wines, the dispenser of the finest intoxication. Entirely, O double

138

virgin, most certainly. Be spiritualised, carnal beauty; and be realised, intellectual phantom."

THE CHOIR: *Procul recedant somnia*
 Et noctium phantasmata!★

"Listen to the conjuration of the voices prized for the purity of their slumber. Nightmares flee, dissatisfied and ashamed, their ugliness prisoned by cloaks the colour of night; and the terrified phantasms fall again into their caverns like heavy fumes. Go to sleep on my shoulder, charming formality of an essence I do not know; sleep, and you will have no dreams but the dream of dreaming."

"I sleep."

★ Let the dreams and phantoms of the night recede into the distance.

INCENSE

The virgin territories of her soul came to know the astonishment of having admitted an utterly unknown explorer. He had amicable ways of insinuating himself: an air of gentle impertinence, the plausible gestures and the disconcerting aplomb of a person who knew his own strength. He measured precisely the consequences of his audacious coup.

Hyacinthe wondered how she had previously been able to utter and listen to such insanities in relation to matters of spiritual delight. Everything was now becoming clear! Rays of light penetrated her closed eyelids; her intellect, freed from doubt, soared like a bird of dawning in an atmosphere of dazzling limpidity. She understood that all the verities, even the most immemorial, were converging towards a central point in her flesh; and that her mucous membranes, in some ineffably mysterious fashion, were gathering into their obscure folds all the riches of the infinite. For one almost-eternal instant she became convinced that her own essence had absorbed and forever taken possession of the essence of everything; this was a possession and a joy so excessive that she fainted.

On her awakening, however, she felt nothing but a great lassitude and an insupportable fear of having been duped. She separated herself without rancour from the chimerical explorer, and pledged to him a certain amity, befitting a companion in a great but fallacious adventure.

I, holding the experience in higher regard, had desired to effect in her a transposition to the minor key of my personal and voluntary illusions. I was pained by the impression that nothing had become manifest in her except surprise. Afterwards she displayed, just as she had before, the sadness of having lived so little; if the sadness was different, it was only that ignorance had been replaced by deception.

I disputed this, but the sensation was already so remote

and so confused that she replied, with that simple frankness permitted by the nobility of our spirits: "It's not much better than eating a peach."

Because sexual pleasure, except that of brute beasts, is only the echo and the resonance of pleasure given, my enjoyment was diminished to the negligibility of the casual refreshment which one might take by plucking a fruit which hangs over a wall while one is out walking – and I doubted the legitimacy of such a defloration.

She acknowledged that there was certain truth in her memory of a flight through the ether – but it was so vague! In the end, by the repetition of similar experiences, her memory was suitably fortified, and she was able to confirm my divination.

"But it doesn't last forever," she added. "However brief or extensive it may seem, the moment is nothing but a moment.

"But nothing exists except moments! One needs only to accept that to capture infinity in a kiss!"

"And then what?"

We began all over again.

Our love-making was physically satisfying, but its aftermath was a humiliating sensation of having achieved happiness through unconsciousness. These stimulations were necessary; they became habitual and we gave hardly any thought to them, outside of each moment itself. We had tried in vain to invest our ceremonies with poetry. They took place in a private chapel at night, to the singing of little girls: liturgical mysteries reverently assisted by an ancient bishop not much given to simony, immediately installed under the umbrella of an absolute venerability, in an old house closed to the commonplace: but there was nothing of the sublime, no extraordinary extremes of sensuality!

Hyacinthe was the daughter of a race which had been dead to the world for centuries. She was an autumnal flower, the last of her kind; she accumulated in her scent all the spirit of the lingering sap, but the youth of her complex-

ion was tinged with something unaccomplished, for want of sufficient sun, like that of a rose leaning over a river of shadows. When she walked, it was as if she were enveloped and carried along by a breath of mystery which played in her blonde hair, like the breeze which lifts and animates the trailing tufts of the guelder-roses along the hedgerows of October.

Condemned by the pallor of her nature to perpetual deception, she suffered only for an instant before becoming resigned. I, on the other hand was fully able to understand the folly of continually trying to realise those alluring dreams – exaggerated by imagination to the status of external realities – which fell away whenever I put out a hand to harvest them.

This was cause for desolation, to be sure, but one fit only for children; the frequent repetition of such failings, however, gradually ruined my innate confidence in being alive. Soon the hand was no longer advanced, so certain was I that it could not come back otherwise than empty.

Contrary to popular belief, such a state of mind is an acquisition rather than a loss; once having arrived there, a man has understood the utter uselessness of movement; he confines himself within himself, qualified at last for serious and authentic existence. He no longer interests himself in anything but thought; his relations with the world are reduced to the strictly necessary, to the urgent maintenance of the material substratum, and all the matters which move individuals and nations, are immediately reduced to the meaningless transactions of an anthill.

Hyacinthe was able to take these ideas aboard: she accepted them, and, scornful of everything else, we occupied ourselves with ourselves, and with the infinite.

For ourselves, there was love. Spiritually, we could only find ourselves in God, after having climbed the mystic mountain, there to suffer crucifixion upon the cross of the eternal Jesus. It was that which I had promised to Hyacinthe, and it was that which she believed that she desired.

Physically, not all the grains of profane incense had been burnt. I did not wish to condemn one who had put her

trust in me to eternal ignorance of an art so generally esteemed, and I unveiled to her all its secrets, wishing that they might inspire repugnance in her.

Curiosity sustained her in this trial, and we methodically exhausted all the articles of the gnostic gospel, without our health being noticeably weakened:

"Extraordinarily excessive sensuality it may be," she said to me one day, "but it all comes down to the same thing in the end, and one means is surely as good as another, since the end obtained is always the same. In any case the exceptional, endlessly repeated, is no different from the banal; and unceasing recapitulation can add nothing, in the end, to the sum of experience. I am weary and hopeless, three times the dupe. Why have you trained me in the shame of abominable sins?"

"In order that you should indeed be truly devoid of carnal hope, so that you would know the humiliation of having an insatiable and deceptive sexuality."

"If we go on this way, I will come to despise you."

"Hyacinthe, your adorable body fills me with horror."

"Damase, your perverse lips sicken my sight, when I see them – afterwards!"

"Your profile is a perpetual joy to me."

"Damase, do you remember when our souls were on better terms – in the mornings of our love?"

"Yes, and you were pure – as pure as the silence!"

"Give it back to me, my primordial purity."

"Confession is purifying, Hyacinthe. Set forth your shame in words, and it is no more."

A VOICE: *Hostemque nostrum comprime*
 Ne polluantur corpora★

"The Word is immanent in the air – and the air, now and then, condenses it in speech. The thought of invisible guardians is always present, all around us, and the circling

★ Restrain our adversary, lest our bodies be defiled.

143

of their wings affords us the protection of their charity. Such beings know our wishes, and realise them when they are not abnormal. They have the power to reach out a metaphorical hand and the voice is often a great helper: they will make it heard if necessary. The enemy is thus cast out of our community, and our bodies are spared any stain – in the future, in the present and in the past!"

"And in the past!" said Hyacinthe. "That which is done can be undone! Even so, I would like to remember. I would like to keep the memory of moments when you penetrated my flesh for the glorification – vain, but luminous – of my womanly sensibility. For, after all, if I am slightly less of a phantom than I was, I owe it to corporeal insistence, and on that count, I have sinned. And I am hardened too by the memory of your unconsciousness, and of all our gestures of love, and above all of that first and so fearful abandonment, of the kiss upon my eyes, of the gauche manner of self-defence against the joy of understanding, of the joy of the bitter apple which we ate together, like children – which, when it is eaten is finished! And after all, whether it be illusion or not, I love you!"

Hear my sighs, O Lord; my sighs have broken the seven strings of the viol, but I shall make seven more with my seven desires.

Hear my words, O folly; your words have broken the strings of my heart, but I shall make seven more with your seven sighs.

"You delight me, Hyacinthe, more than the perfume of the seven roses which are the seven sensualities; the roses are dead, but you still live – oh my love! Yes, as you have said: entirely! Why grieve for the failure of the real? Why not take pleasure, even if it be absurd, in deceptive caresses? We know that the sensation gives nothing, but why should we not amuse ourselves with that nothing – which is everything in the brief moment when it bursts upon our imagination – and remain frankly contradictory, in order

to have the power of smiling within ourselves on tragic occasions."

"Whether or not it is illusory, I love you," repeated Hyacinthe. "And you love me, don't you? In that case, let's be agreeable to one another."

She kissed me on the mouth, and we exalted ourselves with the best madness in the world.

THE ORGAN

"O adorable face which has rejoiced in the stable of the angels, the shepherds and the magi!"

Kneeling before nothing in the middle of her chamber, with her head between her hands and the unravelled innocence of her pale hair extending almost to her waist, she uttered this pious ejaculation in a voice of the utmost purity, having repeated it over and over again, as if it were the amorous strophe of a rosary.

I awaited the continuation; there was none. She picked herself up, smiled at me and said: "I pray for the sake of the music of the words. It is as if that phrase from an ancient book has a strong and gentle music of its own, which sets out to break the doors of negation and to reach, by means of the harmony of its vocal grace, the attentive ear of the Lord Jesus. Yes, attentive, to all that passes here: to the litanies of my secret punishments and the anxiety of making you joyful . . .

"And then, I think of that ancient woman: that Veronica whose good heart won her the privilege of a miraculous handkerchief. Oh, out of all the things that I have done, to move away from the contented crowd of spectators in order to come near to the one who is carrying his cross, and gently, as though with the hand of an angel, to wipe the sweat from the adorable Face! . . .

"And in the sacred images, I shall be seen, standing to one side, with sad Jerusalem at my feet, displaying for the astonishment of the Jews the inestimable imprint, while the condemned climbs towards the summit of the world, his eyes reflecting all his suffering. He is murdered, while I still dwell on earth, arms extended so that what I carry might be venerated, and my attitude preserved until the day of resurrection – for I am the sixth Station of the Cross!"

I replied with disconcerting irony: "Is that what you want? To be a historical figure, so that you might appear

146

in a fresco painted by Fra Angelico, and have your name written on a streamer and repeated, in some apocryphal and indulgent paean, by the angels which accompany you to the Heavenly sphere?"

"Indeed yes!" she replied, blushing. "You would then have picked me out from the work of the great painters instead of the ranks of actual women, and would you not have loved me every bit as much?"

"Every bit."

"Perhaps more?"

"Perhaps more."

"And I would then have revealed to your contemplation nothing but my manner of expression, always the same: a soul more agreeable and certainly less discordant; easier to satisfy and less embarrassed; sure of always pleasing you and never scared at all, as I constantly am. To tell you the truth, Damase, I understand nothing: not you, nor life, nor myself, nor anything else."

"Hyacinthe," I said, "the vainglory of wishing to understand is dangerous, immoral and, above all, old-fashioned. The modern way – perhaps the final way – is to say: Go forward, without knowing why, as quickly as possible, towards an unknown goal! To act and to think are opposites which identify one only in the Absolute. To accomplish all one's movements – of the head, the arms, the legs – without ever quite attaining the status of a puppet, but with a certainty that gives one a feeling of rightness: that is what is nowadays held up as the ideal. Be citizens of universal activity! Forget to be conscious of ourselves! The blind horse gallops without hesitation, not knowing where it is going, not caring where it has been: so let us put out our eyes!"

"You're too impatient, Damase. It isn't necessary to be so sarcastic that it hurts me."

"The more you come to know, the more you will suffer. The Absolute has suffered absolutely, and perhaps suffers still! An infinite sadness has spread itself over the world – whence came it, if not from on high? Think of the

pain which Christ suffered, after the vanity of his atonement, as vain as the vanity which he redeemed! The sacrifice was unappreciated, save only by a few — whose inheritors are numbered today only among the obscure, the imbecile and the defenceless."

"Let us think of ourselves," said Hyacinthe.

"Yes, let us be egotists, and perhaps we will be saved. Salvation is personal. Let's put ourselves first, and unburden of all useless brotherly love the flight of that chimera which carries us away to the stars."

"Shouldn't we love others?"

"We shouldn't love those who choose to do evil; they, by definition, are beyond the bounds of love. But it isn't necessary to hate them, nor to despise them."

"I would like," said Hyacinthe, "to love them just the same — a little."

"No, it's a contradiction in terms: it would be to love the evil that they symbolise."

"But I love brute beasts."

"Brute beasts are innocent."

"Oh, we're becoming such Pharisees!"

That remark stopped me in my tracks. Hyacinthe had reason on her side — to a certain degree. Being practical, like all women, she did not want to close the argument without any hope of a solution; it was necessary to her to retain the possibility of the Brotherhood of Man. I conceded her that desire, lest we should become nothing to one another but sachets of poison.

All the same, I replied: "In all religion, even in that which we practise — and words may render people more disreputable in their own eyes, more permanently, than acts — there is an esotericism: a mystery which, once penetrated, renders all intermediate charity dispensible. Having no relations other than with the Infinite, one abstracts oneself from Creation, and regards one's brothers, bad or good, without any sort of love, effective or theoretical. That is the state of indifference; the night of the will; one of the stages of that dark night of the soul which

understands both sensual and intellectual annihilation – the prologue to life in God; the penultimate state before the beatific vision."

"And what," said Hyacinthe, "is the mystery to be penetrated?"

"Scarcely a mystery, Hyacinthe, although it is as entitled as anything else to a name more prostituted than the conscience of a bishop. It is simply the end-product of reductionist science, more readily acquired by an act of faith than by a logical deduction – although its acquisition is the ultimate goal of logic itself. But what you said is true; it would be Pharisaic to believe that we have achieved that final understanding!"

"Why so, Damase?"

"Are we not different sexes?"

"Yes, yes!" she cried to me. "Yes. I can grasp that: yours and mine. That is all I understand – almost! – and that still saddens me."

"I know that, adorable little liar. You have told me before. It saddens you – afterwards! You pretend to listen to me and all the while you think of love-making. You're like all the others – nothing but a sheath!"

"Couldn't I be that and the other thing at one and the same time? I'm a sheath for your ideas, too – even though they're as rough, sometimes, as a bad dream."

"You're not what you seem to be!"

"Isn't that what you want, Damase? What do you require of me, except to be an illusion?"

When we left the room and the house behind we were received with the deference due to aristocrats by the ancient avenue of respectful and solemn beeches. Suitably grateful to these noble trees we would walk with processional slowness, in harmony with the bending of the large branches which the wind inclined towards our heads, one by one. The great organ made its music: we would listen, our practised ears able to distinguish the sounds of the high and low leaves, the various voices of the surrounding beeches, poplars, pines and oaks. The avenue provided the

dominant notes and, to the precipitous accompaniment of the poplars and the lamenting complaint of the pines, the beeches echoed the grave sonority of a male voice.

All these sounds were pacified by the fall of night; they seemed to descend to earth, re-entering the grass which rustled now beneath our feet.

"In the end," said Hyacinthe, "where do we want to arrive?"

"It seems to me," I replied, "that a strict and positive belief – in ourselves, for example – in our absolute and mystical utility, liberates our logic from a wealth of inconsequences. I fear that we are a little inclined to play. Have you ever stopped, at some time, in a garden in Paris, to watch little creatures, with their hair down and bare-legged, playing with rackets? And have you appreciated the profound seriousness with which, beneath the pleasant appearances, these yapping, sensual animalcules are making shuttlecocks of their souls?"

At the end of the avenue two or three points of light appeared, looming like lanterns above the immobile sea of things. Silently we came to a stop, testing the uncertainties of the unforeseen. Then we imagined the untroubled, predictable lives which were being lived behind the windows of the houses; the comforts of shelter and repose enjoyed by those who were delivered from care of thought, content with a gentle vegetable existence, of slow gestures and few words. Oh, how green the grass is on the other side of the hill!

The church was still open. No one was praying there and the interior gloom slumbered beneath the eternal lamp.

Our knees bumped into the organ which accompanied the choir. I lifted the heavy oak cover from the keys; and Hyacinthe's fingers sang the sad glory of life in the essential and undeniable obscurity. Without rancour against the extinct lights, against the blackness of the sky, they pleaded very humbly that our souls might be granted a glimmer – oh, no more! – a mere syllable of pale flame. As her fingers moved in the half-light, the jewels set in her rings sparkled

a little, as confused as true thoughts: there was nothing there but verity, intermittent and vague, but certain!

And so I lifted myself to the summits of metaphysical desire, all the while caressing Hyacinthe's curls, and following the contours of her ears with an inattentive hand. *There* was a truth of which one could not harbour the least doubt, of whose authenticity one could be frankly certain! Her tresses were as soft as confessions; they surrendered to my fingers and entwined about them so naively, with such an honest desire to please me. Her ear was so disquieting in its sinuosity, but at the same time so docile to my playful manipulation; and Hyacinthe was so completely tremulous and so perfectly in harmony with the gallop of my pulse . . . that the organ suddenly fell silent.

Mindful of the respect due to the spirit of the place, we united ourselves with as much modesty as is compatible with the motions of physical love.

IMAGES

Consider pious images, representations of saints whose wan and emaciated faces are haloed in gold: the beloved released by forgetfulness from all earthly disquiet; those who made their bodies to bleed, who took madness to their hearts. . . .

"Do you believe," Hyacinthe asked me, "that they experienced a purer pleasure than the one we sinners obtain in our sin? Our sin wasn't very pure, was it?"

"Hyacinthe, you are talking nonsense."

"Not at all, Damase, I am becoming real. I am giving substance to my phantom, re-embedding it in the cement of remembered sensation. At one time there was, afterwards, a persistence of sensuality: the permanence of a caress which, going against the grain, had attained my soul and had sensitised it, perhaps forever!"

"Dear spoiled child, it must have been the sin itself!"

"Oh, that is your view. I have no mind of my own, since I made you the gift of my free will, and you accepted it."

"And if I lead you away into the outer darkness?"

"I would follow you, my love, certain of my well-being wherever I were, if I were with you."

That deserved a kiss, which I gave to her; afterwards I said: "It was not a deadly sin."

"Oh, really?"

She mocked me with her incredulity. It was necessary to consult authorities, to prove to her by means of texts the veniality of our abandon. She was irritable in the meantime, but her conceit was mere pretence. I never construed it as authentic perversity, merely as an appropriate determination to move me and spark a contradictory argument.

"A deadly sin," I told her, "is always mediocre. It is, in itself, an incomplete act, limited by its own nature, which only elaborates a worthless pretence. Although contrary to

divine thought, it is held half-way to contradiction, since the absolute in evil is impossible, and inconceivable."

"For myself," said Hyacinthe, "I don't seek the absolute – only, even if they be incomplete, the sensations which might bring me to life. I would be content if they were in vain, if their vanity were gentle to me. You remember how disappointed I was by my initiation, and that afterwards such experiences saddened me, and yet the light of yesterday still lingers in the heart of this mediocre sinner, dear Damase. Why is that?"

"Because irony is one of the elements of pleasure, and because it has become manifest in you irrespective of your swooning beneath the watchtower of the Tabernacle. But there are divine indulgences for these distractions; it is nothing but a failure of etiquette. As for the rest, it's in your imagination."

"And what difference is there, in your view, between the imaginary and the real?"

"Subjectively, none at all, Hyacinthe – as you know very well. All the same, these two kinds of actions, initially differentiated verbally, do not mark the soul with the same kind of scar: thought is denied by thought, action by action. You must not forget that a sin is committed in three distinct modes: in thought, in word, in action. . . ."

"And you really believe that I think?"

"Perhaps without knowing it! Having closely studied women, Schopenhauer was able to establish his theory of the Unconscious: he had come to the conclusion that intelligence can coincide with automatism. His World-Spirit is a woman raised to the Infinite – a most dangerous kind of God under whose government one must expect all kinds of cataclysms; a God unknowable for humanity and unknowable to itself. As for you, little ironic God, I wish I could steep myself in your spirituality – but I cannot. You flee beneath the cutting edge of my intelligence like mad sea-grass beneath the blade of a scythe. . . ."

Hyacinthe seemed inattentive to these images . . .

Scholastica, carrying upon her fist that mystical sparrow-hawk the Holy Spirit, symbolised as a tamed bird, wings spread like a double shield over the breasts of a saint elect.

At the pulpit, gloved hands seize the monstrance and clear eyes weep supernatural tears.

Ida the white, crowned with thorns; and Colette, lamb butchered by love.

On the cross where Catherine was crucified, lilies have deigned to flourish.

Christine, great wings thrust out at her shoulders from her lacerated garments, and the stigmatic wounds in her bare feet bloodying the flagstones of the abbey.

"Well then, understand me," Hyacinthe declared, writhing sinuously upon my knees in such a fashion that she was soon divested of her garments.

The green cushions of the divan became our mediator.

Afterwards, she held me on top of her for a moment, saying to me: "This is how I can be known, and in no other way!"

TEARS

While indulging imaginary sensations and equivalent visions, the impulse came upon me to torment Hyacinthe, very cruelly. I had made her a promise, but an innate goodness of soul and the quest for novelty in our amorous occupations blinded me and pressed me to the naive indulgence of inquisitorial duty.

To administer to souls the one and only drug which can purge them – pain – is assuredly the paramount charity; but how difficult it is to exercise towards the creatures one loves! Innocent victims do not appreciate the value of unmerited martyrdom, and what courage it requires to hear upon the lips one adores the accusation: executioner!

Would Hyacinthe receive my hands as lovers, when they set alight the faggots at the stake; or would she bite them, with teeth poisoned by revulsion?

But it was necessary, and I had another motive too. Tears always bring forth a little revelation of the inner essence – of the perfume enclosed in the secret flask.

"Hyacinthe," I said, shaking my arms villainously, one evening when we had ventured forth yet again to walk in the streets where dry leaves were already weeping, "you are very dull!"

"Oh! What are you talking about?"

That was her usual response, when she was indignant or surprised.

"Stupid, my dear, or perhaps weighted down. Are you tired?"

"Of what?"

"Of following me around, like a shadow!"

She perceived the mischief in my mood, and became sad.

"Like a shadow! But isn't that my duty and my pleasure? When you brought me to life – I know not how – it was in order to follow you, or so it seems to me: to replicate

your ideas and arguments according to the best of my ability, in order that I might eventually materialise in my very substance your counterpart of the opposite sex. Isn't that my role – yes, or no? Why, then, do you reproach me, and why do you make me weep. Am I not the mirror image of your thought?"

"You are as dull, sometimes, as ennui itself – and you have become all too substantial."

"I am that which you wanted me to be," replied Hyacinthe, "and I belong to you to such an extent that when you censure me, it is yourself that you offend."

"She has never realised, the adorable Hyacinthe," I said, my words heavy with atrocious ironic implications, "that that which has begun has also to end."

"I no longer know when it was that I began to love you – which is to say, to live," said Hyacinthe, trembling, "but I do not want it to finish."

"*Imbecila pluma est velle sine subsidio Dei*★. Will only exists to conform to the highest logic. If you belong to me, you cannot want. Can a phantom rebel?"

She became bitter.

"I still have a soul of my own."

"One also speaks of the soul of a violin, or the soul of a bellows – but I concede it to you, Hyacinthe: the immortal soul of a woman, immortally futile and immortally denying. It is that which cramps me, whose emanations rise up like smoke around me, obscuring my vision of infinity. If only you could become as lively as lamplight, O charcoal without flame! But you remain black beneath my breath, and you infest with charnel odours the laboratory of my pure desires."

"Annihilate me, Damase, pulverise the uninflammable charcoal – but be quiet while you do it, so that while I die I will still be able to adore your mute lips!"

"Why do I love you, and say it aloud, since you damn me, and I know it?"

★ Will unaided by God is a feeble feather.

"At least, Damase, don't separate me from your damnation. Let's go together – to Hell itself!"

"You've said all that before. Oh, the stupidity of excessive love! 'My God, I accept damnation, provided only that I may love you!' – isn't that it? But this is mere childishness, more irrational than the broken trajectory of a madman's idea. Damned, you would hate me. Hell is nothing but hatred, and no gleam of phosphorescent joy can ever irradiate pupils consecrated to eternal gloom, even if it originates in the dead eyes of one of the damned who suffers side by side with one for whom she formerly opened the inestimable fountain of her sacrificed heart."

"You're scaring me. You're scaring me!"

Hyacinthe threw herself, dying, into the arms of her torturer. Against all reason, she clung to him in her fright. She kissed the hand which caused her pain; raised up those talons which would rend her breasts; threw herself upon the rack which would break her vertebrae.

Perhaps unable to believe, in the very depths of her being, that I was as nasty as I was making myself out to be, she lifted her terror-stricken eyes towards my own, searching for some fleeting spark of softness, some faint suggestion of precarious consolation. Pitilessly, though. I maintained the sad gravity whose slavery I had imposed upon the muscles of my face.

Kissing her on the forehead, I said: "The greater part of what I have said might be taken back – but the last, no."

Suddenly, I felt the birth and growth within me of a diabolical idea – evoked, doubtlessly, by the specious words which I had earlier spoken.

I overturned Hyacinthe on the divan where she had fallen towards me, and I revelled in the dark pleasure of possessing a woman paralysed by terror.

Urgently twisting and turning, she passed from suffering to pleasure. Even in the midst of the music of sexual excitement, however, she did not entirely lose the discord of distress, which hovered in the balance between the unquestionable violence of her actual sensations and the

fear that when the ecstasy was over the monstrous vice of my hatred might have caught her in its iron grip for all eternity.

I prolonged the experience most carefully, scrupulously judging the appropriate dosages of movement and hesitation, varying the rhythm of the love-making in order to maintain her state of uncertainty. Hyacinthe suffered deliciously, fearful of the contradictions which martyrised her happy flesh: dying of love in an infernal paradise.

In the end, her tears gushed forth in abundance. I drank them, as if they were precious pearls of blood.

THE UNICORNS

When the crisis had passed, Hyacinthe having forgiven me – almost astonished that I needed forgiveness – we were swept resolutely along into the mystical forest, where there are no beasts more wonderful than the timid unicorns. Their skittish flight before her, in such a supremely disdainful manner, provided my lover with the perfect opportunity to regret the loss of her maidenhood. I explained to her that there was an evident merit in such regrets, which made a very fine glaze for her faded soul. Having understood that repentance might be an ornament superior to lost integrity, she consented to offer to Jesus the oblation of those pleasures which had compromised the inborn purity of her fleece.

Metaphor by metaphor we elevated ourselves to the mystery of the Sacrifice. *My Love has been crucified.* The mysticism which we accepted seemed to us to be the supreme dignity of the human soul, disdainful of requiring intermediaries between its own nobility and the infinite nobility of God, between its quotidian agony and the immortal agony of Christ. In accordance with these conclusions we decided that we would henceforth celebrate our own version of the mass, chanted in the theatre of our imagination by a priest and deacons chosen from among the most saintly persons raised by adoration to stand amid the leaded lights of stained-glass windows.

THE FIGURES

Bells, sacred vases, ointments, blessings and baptisms, trumpets and hammers of olden times, semantra and xylophones, balsams, hand-bells, sounding-brasses, cymbals, bells, sacred vases!

The entire hierarchy is summoned to assemble, from the lowest of the low, to those who will become equal in sanctity to the highest saints: all make the sign of the cross upon their breasts.

In the ritual washing, the dirtied holy water moans in the basin like an ocean of conjurations.

Wives, virgins, clerks, laymen: there are no more captive penitents beneath the symbolic fetter of a stone demon; there is no longer a choir of nuns, for the partition is overthrown and the virgin has lost the vanity of her state. There are no more grilles of tight mesh; the sanctuary has been opened. The priest is no longer required to be old; he is young, and his blond hair is gilded by a reflection of concupiscence in the eyes of unveiled matrons.

Only the Poor, in this liturgy, are taken to the door; their duty is to wail, in order that happy ears may be stricken with terror by the cry of eternal misery.

Sepulchres beneath the flagstones exhale an odour of permanent life; ossuaries, a radiance of stars. Reliquaries contain the dust of love.

The chrism has sanctified the altar – thus Christ purifies himself – and, like an imperial flower-bed beneath the aspergillum of the acolytes, the flames of the candles flourish .

The angels pray, simulating humanity according to the dictates of reason, for it is certainly true that they adore essential perfumes, that they have a taste for holy sweetness, that they hear inaudible speech. They are young, strong, free, more fecund than any human loins. They come forth naked, without corruption; if they are dressed at all, it is with the transparency of fire.

At the lectern of the pulpit, regally elevated, is another angel, attended by authoritarian angelic lions.

PRAYER

Jesus, the grains of incense burn in the censer: the Sacrifice catches light and the future offering is complete in desire. The Sacrifice catches light, and becomes smoke, and love extends its dominion over the panorama of the world. The Figures survey their accomplishments.

THE PRIEST: Henceforth, the holy water will be dirtied, and it will mourn for the incorruptible rosiness: bare your heads, for it is the tears of Jesus.

THE CHOIR: Holy Spirit, Spirit of the summits, Spirit radiant.

Spirit prodigious, Light!
Most bountiful consoler,
Most gentle host of souls,
Refuge from the darkness!

THE PRIEST: O Lord, as Thy Son accepted the burden of the flesh, so I cover my shoulders with the yoke of the chasuble. I will go up to the altar, I will go up to the altar of God, the giver of youth and happiness.

PRAYER

The right is the dignity of the King, but the left is reserved to love; it is there that one tastes the plenitude of excess. The hair of John the Baptist is the gentleness of unblemished souls; it receives into a faint heart the caresses of his Mother.

THE PRIEST: He will bless thee, the one for whom thou mortifiest thyself. So let it be.

PRAYER

The incense-boat is a ship, the grains of incense its crew; the incense-boat is a ship without sails or rigging; the

incense-boat is a ship and its flanks are distended with gold. Blessed Virgin and Thurifer, you carry between your hands the barque of Saint Peter, as stable and profound as the breast of God. The incense-boat is a ship and the gold upon its flanks is the peoples of the world: the sacrament catches them and saves them and plunges them into the fiery furnace. The incense-boat is a ship and the censer is the furnace.

THE PRIEST: Perfume rises up above the roses, for roses wilt and wither, while their perfume is an incorruptible oblation.

THE CHOIR: Glory, glory, glory to the Holy Spirit.

EPISTLE

St Paul, Rom: 24★

Wherefore God also gave them up to uncleanness through the lusts of their own hearts, to dishonour their own bodies between themselves: ... For this cause God gave them up unto vile affections: for even their women did change the natural use into that which is against nature. And likewise also the men, leaving the natural use of the woman, burned in their lust toward one another; men with men working that which is unseemly, and receiving in themselves the recompense of their error which was meet.

SEQUENCE

THE CHOIR: O staff and diadem of royal purple.
 Thy gems have flourished with the prescience of elevation since the time when humanity was dormant in man.

★ Actually verses 24 and 26-7 – significantly omitting 25 – of chapter 1. Verse 25 reads: "Who changed the truth of God into a lie, and worshipped and served the creature more than the Creator, who is blessed for ever. Amen." I have reproduced the verses as they appear in the Authorised Version. [FA].

O flower, thou hast not germinated from the dew, nor from drops of rain, and the air has not surrounded thee, but thou wert born upon a very noble staff by the endeavour of Clarity alone.

O staff, thou hast sprung forth all in gold, O staff and diadem of royal purple.

GOSPEL

At that time the Lord, interrogated by a certain Salomé on the time of his reign, replied: "When two become one, and when that which is outside will be as that which is inside, and when the male being upon the female there will be neither male nor female." Salomé asked: "Until which time will men suffer death?" The Lord said: "Until such time that you others, women, will give birth." Salomé asked: "Have I done well, then, having not given birth?" The Lord replied: "Nurse all that is unripe, but suckle not that which hath bitterness." And the Lord said further: "I come to demolish the labour of women, for their labour be generation and death."

THE CHOIR. So let it be.

SERMON

God, we read in St Denis the Areopagite, is neither soul, nor number, nor order, nor grandeur, nor equality, nor similitude, nor dissemblance. He lives not, He is not life. He is neither essence, nor eternity, nor time. He is not science, He is not wisdom, He is not unity, nor is He divinity, nor goodness. Nothing is known of Him but that He is; and He knows nothing of that which exists but that it is. He is not speech, He is not thought, and He can neither be named nor understood.

OBLATION

She has found that her inheritance consists of twelve baskets: twelve baskets of blessed bread.

The Figures are the guardians of mystery, and all the Figures are obedient to the Symbol.

Woman's belly is a sacrificial altar, the first station of Calvary, the first dwelling chosen by the Host: obscure oblation, bloody prelude of Transfixion.

PRAYER

The paten carries peace.

Mary, haloed in red, lifts up to a purple dais the Infant-King, while two angels offer the stormy fumes of their censers. Jesus and the angels are similarly aureloed in blood, and in the blue sky gilded with stars thunderclouds are heaped up, the colour of anger and the colour of peace: the colour of blood.

ANTIPHON

The Lord laid himself down to sleep in his royal bed, but the balsam of my love has penetrated his slumber, and the Lord has risen up and said: "I will enter into the body as a good odour, and I will sleep there."

THE ORGAN: From the gloom of profound exile, the soul with a single bound is exalted to the vivid blue of hope, and then becomes profuse with laudations the colour of the sun.

Glaucous waves surge in the abyss, and the ocean of fear rises up in green foam, but a hand appears upon the face of the troubled waters and an invisible censer distributes an abundance of violet fumes.

Human waves swell up towards the sky. Within the transfigured bodies hearts flutter like roses in the morning wind, and the eyes are amethysts of the utmost purity. Candid clouds disrobe breasts tremulous with love, and all rise up to heaven in the absolute whiteness.

THE CHOIR: *O salutaris Hostia*
 Quoe Coeli pandis ostium★

★ O sacrificial Victim, who opens the door of Heaven.

PRAYER

Magic of terrifying supernaturality, O absolute power, invincible domination of words, marvellous function of syllables: *Verba consecrationis efficiunt quod significant.*★

ELEVATION

The host is elevated in the solar flames. The Lamb tarries and bleeds upon the earth.

THE PRIEST: Remember, Christ our Lord, the slumber of peace. Grant us the peace of the tomb and the sacred silence of the necropolis.

JESUS CHRIST: You will sleep in peace for three days, if you love me, and the stone of your tombs will break, and you will know Life, if you have known love.

PRAYER

Kisses are the settlers of ancient disputes; kisses are the pacifiers of the body.

COMMUNION

Flesh of the Sacrifice, Blood of Eternal Joy, be the maceration of my flesh and the appeasement of my blood. I will crucify my desires upon the cross of Calvary; I will crown my thoughts with the crown of thorns: I will drive into my side the lance of renunciation; I will drink the vinegar of derision and no pleasure will ever diminish my soul.

JESUS CHRIST: Pleasure ends in unity but the dolours are numbered seven times seven.

THE CHOIR: Compassion! Compassion!

JESUS CHRIST: All is accomplished.

THE PRIEST: *Ite, missa est*†.

★ The words of consecration bring about what they signify.

† Go, this is the dismissal (this is the formula which ends the Latin mass).

GOSPEL*

In the beginning was the Word and the Word was with God and the Word was God.

The same was in the beginning with God.

All things were made by him; and without him was not anything made that was made.

In him was life; and the life was the light of men.

And the light shineth in darkness; and the darkness comprehended it not.

Amen.

* These are the opening verses of the gospel according to St John; I have rendered them into the English of the Authorised Version.

LAUGHTER

We heard this mass sung in a Benedictine monastery, under a stained-glass window like frosted leaves fallen in the dew of dawn, amid the glory of white crucified with gold. Grace coursed from the blessed host when the monstrance was lifted above the wimples of the nuns, and we were blinded by the inexhaustible waves of the sacred blood of the Redemption.

We heard it sung, too, in the sepulchre of the Carmelites, amid the gloom further darkened by all the mournfulness of the grille and the veil – for there is no joy at all for those trapped in the flesh – and we fell to our knees, bruised by stupor and affliction, ready to beg forgiveness from these expiatresses of our pleasures, dying in perpetual agony. It seemed to us that to kiss one of those bare feet would be an act of indulgence and absolution.

"The obligatory exultation of the Benedictine," Hyacinthe said to me, "is perhaps more frightful still. It requires of them a sumptuousness of the heart which is truly disconcerting. . . ."

"Yes," I replied, "but the ideal of being glorious is less contradictory to human instincts. It is only a paradisal development of the universal tendency to open out and to enjoy. However, what you say is almost true: the joy of a nun contemplating the Resurrection is as far beyond the mediocrity of womanhood as the sacred sorrow of she who weaves in the perpetual night her own shroud and the shroud of Christ . . . Consider also how far away they are, these individuals who live among us and yet are strangers to the march of our lives. If we were more of our own time, Hyacinthe – you, plucked like an ancient flower from a Flanders tapestry, and I, who have abolished all contact between my soul and vulgar humanity – if we were truly of our time, the mere existence of a few hundred of these disdainful virgins would be an insult to

our incontrovertible modernity. And in order not to be angered by these inoffensive fools who do not draw from life a single drop of alcohol or poison – for in our understanding they would seem like infants without experience, equally inapt in the joys of the bed, the table and the stage – and in order to leave no lingering doubt as to the advantages we enjoy as civilized citizens, we would force ourselves to laugh."

At that point I took out of a box a large sheet of Dutch paper, where the hand of some primary schoolteacher had condescended to write for me a few precious lines – in which, I dare say, the soul of regenerated France is manifest:

Chamber of Deputies

Parliamentary Debates
Session of 9th December 1890

Official Account

M. B. *"The Carmelites, a contemplative order (laughter to the left) . . ."*

Hyacinthe was affrighted by the prospect of living under such a stupid dominion. We believed for an instant that the time predicted by Flaubert was upon us.

"But what does it matter?" I said, replacing the document in its box. "We are not responsible for these imbecilic claims; we suffer them and pass judgment upon them. As the bog engulfs and devours these brethren of ours we watch them descend – and when the tops of their heads sink beneath the surface of the mire, we shall place heavy stones there, lest the interior of the earth might vomit them forth again in disgust. Ah! I wish I had the courage to work for the debasement of my contemporaries. What good work it would be to defile their daughters: to insinuate something obscene into the infantile hands which caress each paternal beard and cheek; to poison them, even at the

risk of perishing ourselves; to do as those Spanish monks did who drank death in order that they might persuade the French rabble which had violated their monastery to do likewise!"

Hyacinthe calmed me by means of those secret ways which she shared with all creatures of love – and we slept.

I dreamt that in order to spare her the foulness of the present I had consigned her to the closure of Carmel. In the evening, at the hour of the office, I went into the night-chapel to listen to the voice of darkness – and in the chorus of the veiled voices of mourning, I distinguished the voice of my dear lover, dead and forever Hyacinthe.

Never did I have a more beautiful dream.

FLAGELLATION

In our study of mystical lore we sometimes encountered words which scandalised my loved one, but I interpreted them for her, with all the deference due to texts written by great saints. She learned that the caresses of my left hand, which were the first to be suffered, were proof of the acceptability of the sacrifice; while the caresses of my right hand comprised the entire bloody manual of love: the kiss of thorns; the touch of leaded whips; the adorable bite of nails; the carnal penetration of the lance; the spasms of death; the joys of putrefaction.

We meditated upon this nomenclature. Hyacinthe became overexcited, scornful of her corporeal appearance; and she decided to put her contempt to an actual test.

One evening, I was reading the life of St Gertrude, the patron saint of ingenious delights, whose divine caprice it was to replace with cloves the iron nails of her crucifix. I had reached the page where Jesus himself, in order to delight his wellbeloved, descends towards her, and taking her in his embrace, sings:

> *Amor meus continuuus,*
> *Tibi languor assiduus,*
> *Amor tuus suavissimus*
> *Mihi sapor gratissimus . . .**

I was searching for the further significance of these four lines when Hyacinthe appeared before me completely naked, begging me to flagellate her. She had in her hand the scourge of a canoness: seven cordlets of silk in detesta-

* My love [is] continuous,
For thee languor [is] incessantly present,
Thy love most sweet [is]
For me a most pleasing savour . . .

tion of the seven deadly sins, with seven knots to each cord in remembrance of the seven ways of mortal failure.

"The seven cords of the viol!" she said, smiling strangely. "The roses will be the drops of blood which flower in my flesh."

Hyacinthe had no more modesty than any other woman of her race, but only penitential ardour could explain her boldness in displaying herself before me entirely nude, without any attempt to use her hand to veil the sexual secrets of her scarcely-nubile body. Her body was so youthful, so utterly frail, of such Athenian purity of form, as graceful as an unconscious Eve, that my heart quailed at the prospect of bloodying its innocence.

Nevertheless, I obeyed her. Blood-red lines and spots stigmatised the shoulders of my lover, and her buttocks, and her back. Some of the stinging blows strayed towards her belly and the candour of her frightened breasts.

She fell to her knees, hands joined together although her arms were outspread and lifted. She bent her back, but raised her pale head in excitement, crying out whenever the flail was slow to descend: "Again! Again!"

I am sure that she had the illusion of being an earnest martyr, of receiving a thrashing worthy of Henry Suso or de Passidée, who were found in their cells having fainted in a stream of blood while tattered shreds of flesh clung to the iron spurs of the heavy martinets which had fallen from their weary fingers in spite of their determination to suffer untiringly. In fact, I had been as clement as I could, desiring to satisfy her caprice but not to pollute with scars a skin whose integrity was so dear to me.

"Again! Again!"

She looked up at me with eyes en route towards ecstasy, eyes whose whites already ate away at the radiance of the pupils like an eclipse. Within the partially-occulted iris, a cruelty which was not the executioner's sparked the mad glimmering of little lightning-flashes and sharp-pointed flames.

All of a sudden, she came to her feet. Her arms fell

171

about my neck and she collapsed, dragging me with her into an unforgettable abyss of voluptuous excess – and we dwelt in its utmost depths forever.

THE RINGS

After that crisis of bitter debauchery we perceived in our exhausted faces the ironic expressions of those who have nothing more to desire from one another. We hardly spoke any longer. Hyacinthe sang softly and insistently, laid low by virtue of having emptied, to the very last drop, the golden chalice of Babylon.

These days of disenchantment afforded me an opportunity for careful reflections. I perceived all the dangers inherent in our mysticism *à deux*, and I repented of having associated a woman with products of the imagination which were so disconcerting to reason and to corporeal equilibrium. I felt that the more I had desired to elevate my lover in intelligence and in the experience of love, the more pleasure she had taken in falls and somersaults. She had the artistry and the audacity necessary to conclude and confuse all upward thrusts with a downward thrust, following the dictates of her own nature, which was evidently heavier than the air of spirituality.

It seemed to me that because she was always lying in wait for my gestures and my opinions, in order that she might ingeniously conform to them, I had in the end succeeded in imposing upon her essence none but negative notions. Like some Fakir who could empty a gourd by the magnetism of his stare, she drank the very thought from my expression, contradicting in advance that which I intended to offer, in order that she might afterwards claim the merit of having been persuaded. Could she have any life of her own, apart from me? How could I tell? Very little, according to her own account – and I believe that it was true, for she never manifested any original desire, and the responses of her inner self seemed to be entirely determined by the immediate sensations which she experienced by means of intellectual and sensual contact with my personality. If the shock of such a contact was too violent,

the fibres of her being became deadeningly congested, her resonance mute, and I felt that she was no closer to me than some obtuse animal capable of nothing but sterile imitation.

That was what happened after the night of the flagellation. She fell once again into barrenness, equally devoid of physical desire and spiritual love; her flesh utterly indifferent once more. I found myself helplessly forced to come full circle, to renounce the project of mystical ascension; corporeality had become, in the wake of my experiences and my observations, both the means and the obstacle, the motor and the brake, of superhuman elevation.

Given that I had made a mistake, there was nothing to be done save to return the woman to her natural state, and to resume on my own account the ordinary course of a life without indiscreet aspirations. Our paths undoubtedly lay in different directions: we could not possibly organise for ourselves a perfectly ordinary, honest and mediocre existence; our eternal destiny was all or nothing – and only the final parting now remained.

One evening, I knelt down beside the divan where she was perpetually laid down, eyes unfocused, lost in a dream. Discreetly, with no intention other than to arrange its folds aesthetically, I had undone her evening-dress along its entire length. Seething about her naked body, the material simulated the foam of that wave which, having carried Hyacinthe to where she lay, would now perhaps carry her away again. With child-like curiosity I watched her breathing, trying playfully to excite some revolution in the confined undulations, suppressing with my open palm the rebellion of her belly. Her breasts fled, disappearing like magnolia blossoms covered by the snow. I amused myself by following with my eye and my finger the course of her veins, which eventually lost themselves, like rivulets of sap among the golden efflorescence of jonquils and marigolds.

"Do you like this amethyst?" she asked me, plucking an old ring from her finger. "It's oriental, isn't it? I found it in my jewel-case, underneath a pearl necklace."

She got up, nonchalantly readjusting her dress by re-engaging several of the hooks and eyes. Then, having emptied out the rings from her jewel-case on to a piece of black velvet, she lined them up, turned them towards the light, and tried them on her fingers.

"Do you always enjoy being in the country, Damase? For myself, I would like to look again upon that great drawing-room where we first met, and see all my sisters – pale girls uncoloured by the ages – and return for a while to the graceful chorus. And I would smile at you, Damase, as you passed along the length of that ancient tapestry. . . ."

The room seemed to me to be full of funereal shadows. I opened the window; looking out into the night, I saw further than the night; listening to the silence, I heard more than the silence.

"The pre-emptive clarity and sonority of the matinal bells which guided me towards Hyacinthe; the understanding of our souls anterior to the union of our senses; the first spoken words of my lover, so ironic and so highly rational from the moment that she had moved towards me; her insistence on saying that although she was living, she was also as dead as an apparition woven in wool and coloured by dreams. Living! I believed it, and so I dedicated her to Pain, while she dedicated herself to the joy of exploring the sensations of sexual novelty. I acceded to that double desire, which is not at all contradictory, because I wished to magnify her soul; I deflowered her, as was required, in order that she might flourish – was all of that an illusion? When she confessed to me: 'It's not much better than eating a peach' but declared nevertheless that she wished to enjoy further contact with me – and when her feelings were hurt by certain over-ingenious ways of love-making – and when she prayed – and when she wished to understand – and when sacrilege exalted her – and when she jeered at me, defying me to untie the knot of her complexity – and when I put her on the torture-rack – and when she wept – and when we climbed, moist with the sweat of

sin, the obscure mount of Calvary – and when I thrashed the impertinence of eternal femininity upon the nakedness of her back – had she not all the gifts 'essential to life'?"

The voice of silence replied to me: "All the gifts essential to the dream."

I came away from the window. Hyacinthe was still playing with her rings. She was very pale; it seemed to me that rays of light were traversing her body – that body which nevertheless gave honest testimony to my hands of its evident reality and carnality.

I was cold, and I was afraid. Powerless to oppose the dolorous transformation, I saw her going to rejoin the company of those irresolute women of whom my love had tired. I saw her becoming once again a phantom, just like all the rest.